CONCERT AND
LIVE MUSIC
PHOTOGRAPHY

CONCERT AND
LIVE MUSIC
PHOTOGRAPHY

pro tips from the pit

J. DENNIS THOMAS

AMSTERDAM • BOSTON • HEIDELBERG • LONDON
NEW YORK • OXFORD • PARIS SAN DIEGO • SAN FRANCISCO
• SINGAPORE • SYDNEY • TOKYO

Focal Press is an imprint of Elsevier

Focal Press is an imprint of Elsevier
225 Wyman Street, Waltham, MA 02451, USA
The Boulevard, Langford Lane, Kidlington, Oxford, OX5 1GB, UK

Notices
Knowledge and best practice in this field are constantly changing. As new research and experience broaden our understanding, changes in research methods, professional practices, or medical treatment may become necessary.

Practitioners and researchers must always rely on their own experience and knowledge in evaluating and using any information, methods, compounds, or experiments described herein. In using such information or methods they should be mindful of their own safety and the safety of others, including parties for whom they have a professional responsibility.

To the fullest extent of the law, neither the Publisher nor the authors, contributors, or editors, assume any liability for any injury and/or damage to persons or property as a matter of products liability, negligence or otherwise, or from any use or operation of any methods, products, instructions, or ideas contained in the material herein.

Library of Congress Cataloging-in-Publication Data
Application submitted.

British Library Cataloguing-in-Publication Data
A catalogue record for this book is available from the British Library.

ISBN: 978-0-240-82064-4

For information on all Focal Press publications
visit our website at www.elsevierdirect.com

11 12 13 14 15 5 4 3 2 1

Printed in China

Working together to grow
libraries in developing countries

www.elsevier.com | www.bookaid.org | www.sabre.org

ELSEVIER BOOK AID International Sabre Foundation

"I know it's only rock 'n' roll, but I like it."
 -The Rolling Stones

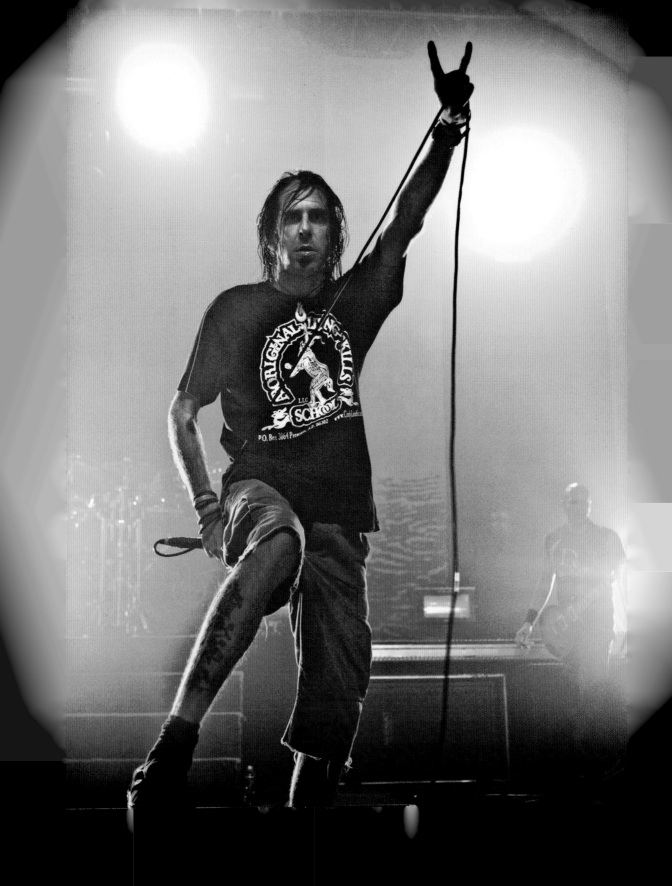

AR

Before you can start taking concert photos you need the gear. As with any type of job, from auto mechanics to information technology, having the right tools makes it infinitely easier to get the desired results. The right gear doesn't necessarily have to be the newest or the most expensive, but it should have the attributes you need to get the job done.

There's a tendency among some photographers to get into debate over which camera systems are better, Nikon vs. Canon vs. Sony, etc. I won't be covering that topic here. For all practical purposes, a camera system has one purpose, which is to collect light and to record an image.

A common question that I get is, "What gear do I need to get started?" The short answer is that you can do concert photography with even the most basic gear, but as with any type of photography there is specific gear that will make the job easier, and there's an almost infinite amount of gear and gadgets that can be acquired.

In this chapter I'm going to cover the basic necessities of a camera system: the camera body and the lenses, and the pros and cons of the different types of each.

CAMERA BODIES

Every camera manufacturer has numerous types of cameras, from the basic entry-level camera to the high-end professional model. Each level of camera has strengths and weaknesses, and even the top-of-the-line professional camera may have some attributes that you may not want or need.

If you're in the market for a new camera you should sit down and assess your wants, and more importantly, your needs, before you rush out and buy the newest, most expensive camera on the market. A lot of times you don't need all those bells and whistles, and they can be a hindrance when it comes down to the real work of actually shooting.

Resolution

Probably the first thing people look at when buying a camera is the resolution. The number of pixels on the camera's image sensor determines the resolution of the camera. Resolution is expressed

When you're looking at purchasing a camera using mega-pixels as a measuring stick, one great thing to keep in mind is what the output of your images will be. If you are planning to print your images at a large size, more resolution is better, but if you're only planning on posting your images to the Web, a camera with less resolution will suffice. For all practical purposes a camera with 12 megapixels is usually more than enough resolution for almost any application.

Keep in mind that with a higher resolution your image files are also larger, resulting in longer transfer times that can fill up the camera buffer faster, which may cause the camera to bog down when shooting in bursts.

Bottom line is that these days most camera manufacturers use resolution as a marketing tool. A camera with 24 megapixels isn't necessarily twice as good as a camera with 12 megapixels. In truth, especially when dealing with the kind of low-light photography that concert photography often is, the 12 megapixel camera will outshine the model with the higher megapixel count.

Build and Durability

Two of the most important things to consider when looking at a camera for concert photography are build and durability. If you're considering making this a career, you're going to want a camera that is built to take the rigors of heavy use. Concerts held in

1.2 *While photographing the popular Austin punk band the Lower Class Brats at a tiny venue in Austin, the air was damp with sweat, condensation, and especially beer. Taken with a Nikon D700 with a Zenitar 16mm f/2.8 fisheye lens; ISO 200 for 1/4 sec. at f/5.6, TTL flash on, spot metering.*

1.3 *As you can see here, while photographing the performance metal band GWAR at the Austin Music Hall, I was repeatedly doused with "alien blood" and "slime." The weather sealing saved my camera. Taken with a Nikon D700 with a Nikon 14-24mm f/2.8G at 14mm; ISO 2000 for 1/200 sec. at f/2.8, spot metering.*

Another good point of a magnesium-framed camera is that when using heavier lenses such as a 70-200mm f/2.8, you have less of a chance of warping the lens flange if you have the camera and lens hanging from a strap. Although quite rare, plastic-bodied cameras have been known to warp slightly from the weight of the lens and in a few ultra-rare cases the lens flange has ripped completely from the body.

Smaller entry-level cameras are usually manufactured from a durable poly-carbonate plastic. These cameras have the advantage of being much lighter, which can be a real asset when shooting an all-day-long festival. If you're not planning on doing a lot of heavy shooting, this may be a great lightweight option for you.

ISO Capabilities

The ISO capabilities of a camera are one of the more important features of a concert photographer's camera. The better the ISO capability of your camera, the less noise you will see in your images, which results in images that are cleaner and much sharper.

Another facet to a camera's ISO capabilities is how the sensitivity can be set. Most newer cameras have the ability to set the ISO sensitivity to at least 3200 to 6400. Keep in mind that not all cameras are created equal: different manufacturers use different image processors and sensors, which can affect how much noise appears in your images at a given ISO setting.

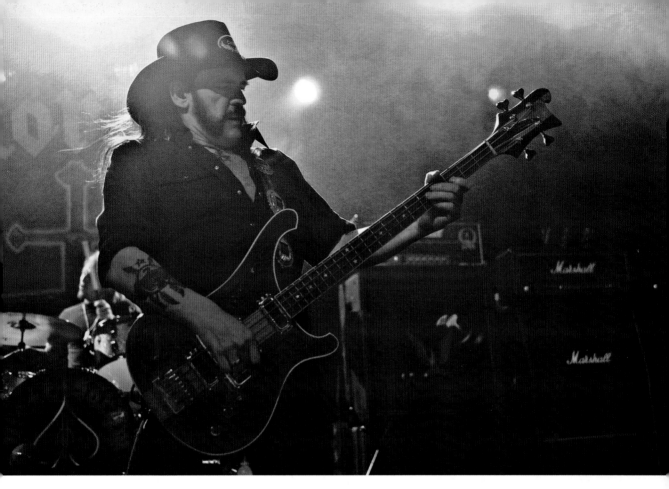

1.4 *The Nikon D700 is known for it's exceptional capabilities at handling high ISO settings with little to no noise. This image of Lemmy Kilmister of the legendary metal band Motörhead was shot at ISO 3200 and has no noise reduction applied at all. Taken with a Nikon D700 with Nikon 28-70mm f/2.8D; ISO 3200 for 1/200 sec. at f/2.8.*

Camera resolution also plays a role in the camera's ISO capabilities. Cameras with larger sensors and lower resolution have larger pixels, which are more efficient at gathering photons of light, which in turn translates into images with almost no noise even at ISO 6400. The Nikon D3s is a 12 megapixel camera with a full-frame sensor that turns out pristine images at ISO 6400 with a top ISO setting of 12800 while the D3x with it's full-frame 24 megapixel sensor is limited to ISO 1600, with ISO 800 being the usable limit (in my personal opinion).

Full Frame vs. Crop Sensor

In the earlier days of digital SLR photography this was more of a consideration than it is today. Since the selection of lenses that are available for crop sensor cameras (cameras with sensor smaller than a frame of 35mm film) has made the

problem of obtaining a true wide-angle field of view a nonissue there are other things to take into account, namely concerns about ISO capability and the ability to get a *smaller* field of view from lenses with longer focal lengths. When using a crop sensor the camera magnifies the image either 1.5x for Nikon cameras, or 1.3 or 1.6x for Canon, depending on the model. This allows your 70-200mm lens to give you an equivalent field of view of a 105- 300mm lens on a full-frame camera.

An advantage of having a full-frame sensor is that the pixel pitch is larger in comparison to a smaller sensor with the same number of megapixels. Larger pixels are more effective at capturing light, which allows the sensor to produce images with less noise.

Autofocus System

Autofocus, or AF, as it's commonly referred to, is a great feature for a concert photographer, but it's only useful if it actually *works*. Different cameras have different AF modules, and not all of them work the same. Some cameras focus great in bright light but can hunt for focus when the light is low, which obviously is going to be the norm when shooting a concert. Faster lenses with larger apertures are a great help at speeding up the AF.

There are two types of AF sensors found in cameras today, horizontal and cross-type. Cameras that have AF modules with more cross-type sensors are usually quicker at achieving focus in low-light because they are better at detecting contrast (which is how the camera determines focus). Most cameras have at least one cross-type sensor that is often in the middle. Higher-end cameras usually have five or more, with a camera like the Nikon D3s having fifteen cross-type sensors out of fifty-one.

The number of AF sensors should also be a consideration. The more sensors you have the better the ability to pinpoint your focus. With a camera that has a limited amount of focus points you may have to lock focus on the area and recompose the frame slightly to get the right composition. This takes only a fraction of a second, but gives the performer just the right amount of time to move enough that your focus can be off.

While having a lot of focus points can be beneficial, sometimes they can also be a drawback: using the multi-selector to navigate amongst 51 focus points takes a lot longer than it does to navigate through 11 points. You can also miss a shot simply while trying to navigate to the right focus point for the composition. Fortunately, most cameras with a high number of focus points have settings that allow you to reduce the number of available focus points in use, making it quicker to get to the point you want to use.

Most cameras these days have AF systems that can track the subject if it moves away from the selected point. It's referred to a number of different ways, such as predictive focus tracking, 3D tracking, or some other variation depending on the camera make and model. I do not recommend using this type of AF setting when shooting concerts or live music. The flashing lights and quick movements usually overwhelm the AF system, making it unreliable.

Vertical/Battery Grip

In my opinion, this is one of the most important accessories you can get for your camera. Most top-of the-line professional cameras such as the Nikon D3s and the Canon EOS-1D series have this built-in. Not only does having a vertical grip make framing vertical shots much easier for you, it also helps you avoid interfering with other photographers in the pit.

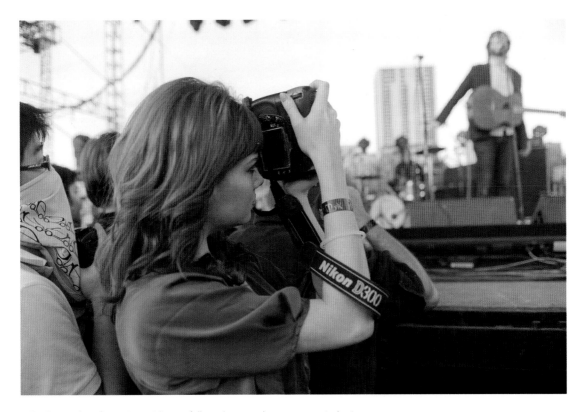

1.5 *To avoid confrontations with your fellow photographers use a vertical grip.*

My colleague Randy Cremean related a story to me about his first-ever big concert shoot: "A crusty old pro slapped my elbow and told me to turn my camera the other way when I went vertical so the elbow wouldn't be up in the air, blocking people behind me." The vertical grip allows you to hold your camera normally so as to avoid the *elbow in the air* syndrome.

Most vertical grips also offer the option of having an extra battery or even a larger battery with more power, allowing you to shoot more images without running out of juice. This option comes in particularly handy when doing all-day shoots at festivals.

The vertical grip also adds more weight to your camera. When using large pro lenses, this can offer an improvement in ergonomics, making the camera more evenly balanced.

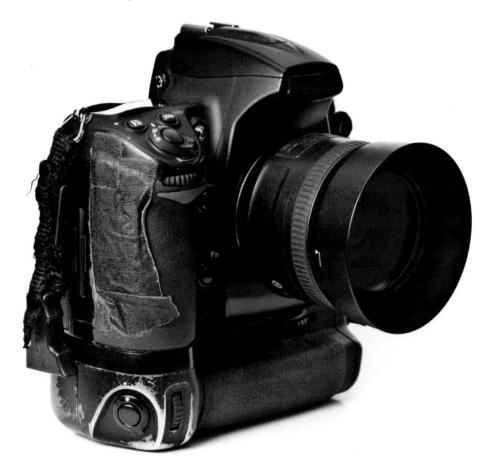

1.6 *My trusty Nikon D700 with its well-worn vertical grip the MB-D10 attached.*

LENSES

Arguably the most important part of your camera kit is the lens. Even with the most expensive camera body money can buy, if you put an inferior lens on it your image quality is going to suffer. In these days of digital SLR cameras, it seems that a new camera with more and better features is always being released. For practical purposes, if you're a pro or semi-pro, you can expect to upgrade your camera every two to three years. In contrast, a good lens can last a lifetime if properly cared for. The Nikkor 28-70mm f/2.8D AF-S is my main workhorse lens, and it is more than ten years old. I've gone through more than a dozen camera bodies in the same timeframe. Although it doesn't have some of the features of the newest lenses, it's still a high-quality pro lens that gets exceptional results.

Focal length and aperture are the two main features to look at when selecting a lens for concert photography. Focal length determines the *angle of view* of a lens, or in lay terms, how much of the scene you can see in the frame. Wide-angle lenses have lower numbers and fit more of the scene into the frame, while higher numbers have a narrow angle of view and allow you to focus on a smaller part of the scene and help to pull far-off subjects close into the frame. From wide-angle to normal to telephoto, each type of lens has its uses in concert and live music photography. I cover each different focal length category individually in the following sections.

Zoom vs. Prime

This is a bit of a sticky subject, but it's definitely one that needs to be talked about. The main difference between a zoom lens and a prime lens is that the prime lens has a fixed focal length. Prime lenses are available in all types, from ultra-wide to super-telephoto and everything in between. Prime lenses are often sharper than zoom lenses, but in recent years zoom lens technology has grown by leaps and bounds. A lens such as the Nikon 14-24mm f/2.8G, or example, is actually sharper than either the Nikon14mm f/2.8D or the 24mm f/2.8D prime lenses.

One of the main advantages to a prime lens, however, is that it can be made with faster apertures than zoom lenses because there are less lens elements to deal with and it can be made in a smaller package.

It never fails that whenever I see an online discussion about what lenses are recommended, there is always a percentage of people who say, "Get a fast prime" This sounds like the obvious answer due to the fact that most concert and live music venues are low-light situations, but the truth is that most of the professional concert photographers I work with do *not* use prime lenses, and there is a very good reason for that. Composition. Generally when you are doing this type of photography, you are confined to a very small space with a number of other

photographers in there with you. A prime lens severely limits your ability to get a great composition. More often than not you end up cutting out guitar headstocks, appendages appear to be severed or hands appear to be floating at the edge of the frame. When using a wide-angle prime, your subject can appear to be very small in the midst of the frame. A zoom lens allows you to actively compose your shots while shooting in a small area, which is a great advantage over fixed focal-length lenses.

Composition is one of the most overlooked facets of concert photography, yet it is very important. For this reason I hesitate to recommend a prime lens for most concert photography work.

Aperture, Fixed vs. Variable

The aperture of the lens determines how much light can get through the lens and subsequently to the sensor. For concert photography, the more ambient light you can capture the better. More light equals lower ISO settings and/or faster shutter speeds, which keeps the noise down and the subject sharp, respectively. Zoom lenses come in two distinct types, fixed aperture and variable aperture. A fixed aperture zoom lens maintains the same aperture as you zoom in and out. These lenses are usually more expensive and generally have apertures of either f/2.8 or f/4. Fixed aperture lenses are preferred for concert and live music photography, because they give you more consistent exposure settings across the whole zoom range.

Variable aperture lenses have a lens opening that gets smaller as you zoom in to longer focal length settings. This is very important, because your exposure changes as you change the focal length and may impact your image quality. Almost all *kit lenses*, or lenses that are bundled with cameras, are variable aperture and usually start out at f/3.5 and end up at f/5.6 on the long end. While f/3.5 is a relatively fast aperture, when you zoom in to longer focal lengths, shooting at f/5.6 can cause quite a problem due to the longer shutter speeds and higher ISO settings required to get the exposure settings that are needed. Some companies offer so-called *fast variable aperture lenses* that start out at f/2.8 and end up at f/4. I have a Sigma 17-70 f/2.8-4 that is a pretty good and affordable lens. Although I don't recommend using a variable aperture lens if you don't have to, these faster ones will work fairly well, especially if you're on a limited budget.

Wide-Angle Lenses

Wide-angle lenses allow you to fit a lot of the scene into the frame due to the large angle of view. The focal lengths of wide-angle lenses usually run from about 10-24mm on a crop sensor camera and from about 14-35mm on a full-frame camera. There are also fisheye lenses that run anywhere from 8-10.5mm on crop sensor and about 15-16mm on full frame. Fisheyes are special types of wide-angle lenses that aren't corrected for the lens distortion and appear to be very bowed, especially at the edges of the frame. Most standard wide-angle lenses are considered to have *aspherical* lens elements to correct for most of the lens distortion.

Wide-angle lenses can give your images very dramatic looks because of the distortion they can impose on the image. There are two types of distortions that are typical of wide-angle lenses. The first type is *perspective distortion*; this type of distortion causes things that are close to the camera (foreground) to look disproportionately larger than things that are farther away from the camera (background). Although this effect is traditionally terrible for portraits, when used in concert photography it can add a real cool effect that can help your images stand out from the pack.

The second type of distortion is a symptom of the aspheric elements in wide-angle lenses that are used to stop the images from appearing bowed out near the edges (as you would see in a fisheye). The byproduct of these aspherical elements is that near the far corners of the frame things start looking as if they are stretched out. When shooting a landscape photo this may not be readily noticeable, but when introducing a person into the frame it may become very apparent. Once again, this effect can be used creatively.

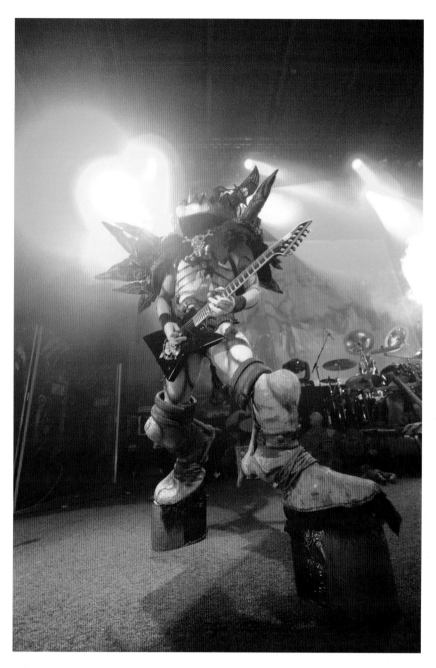

1.7 *In this image of Balsac The Jaws of Death, the guitar player of GWAR, his foot looks disproportionately large in comparison to the rest of his body due to perspective distortion. Taken with a Nikon D700 with Nikon 14-24mm f/2.8G at 14mm; ISO 3200 for 1/200 sec. at f/2.8.*

1.8 *Composing the image by placing Tim Armstrong of Rancid near the edge of the frame allowed a cool stretched-out effect to happen. Taken with a Nikon D700 with Nikon 14-24mm f/2.8G; ISO1600 for 1/200 sec. at f/2.8.*

Since concert photography doesn't necessarily need to be *representational* or show proper spatial relations, wide-angle lenses can be used creatively with very interesting results. I do, however, recommend using it sparingly, for as with any special effect, when used too often the effect can appear to be gimmicky and lose its impact with the viewer.

The main thing to remember when using a wide-angle lens is to fill the frame with the subject. Having the subject very small with a lot of distracting space around him or her is the surest way to make your image lose impact. In very few occasions this can work, but generally only with big stage productions where the background isn't very cluttered with distracting elements like roadies, guitar stands, and other miscellaneous things.

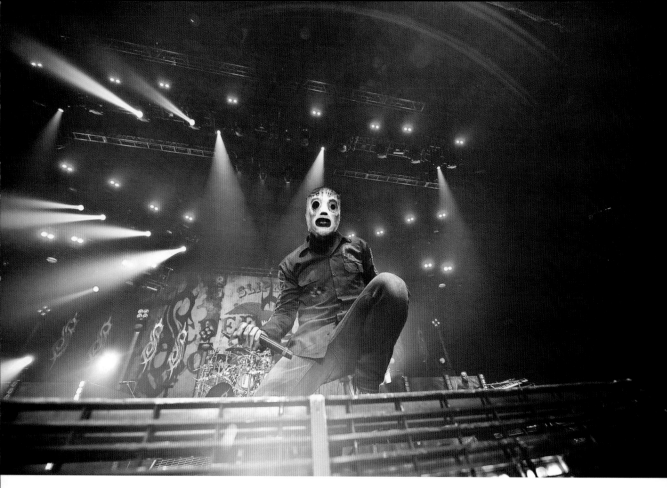

1.9 *In this shot the wide angle is used to show off the stage setup as well as Corey Taylor, the singer of the band Slipknot. Taken with a Nikon D700 with Nikon 14-24mm f/2.8G; ISO 360 for 1/100 sec. at f/2.8.*

One caveat with using wide-angle lenses is that in order to make the image more dramatic and have the subject fill the frame, you need to get quite close to the subject. Most performers do not like to have photographers invading their space, so keep that in mind when using wide-angle lenses. I have seen photographers ejected from photo pits because they jammed a fisheye lens into the face of a performer.

Mid-range or Standard Lenses

A mid-range or standard lens is the lens you'll most often find on your camera. These lenses usually have a focal length that starts out marginally wide and zooms in to a short telephoto lens. Typical focal lengths go from 17-50mm for crop sensor cameras and 24-70mm for full-frame cameras.

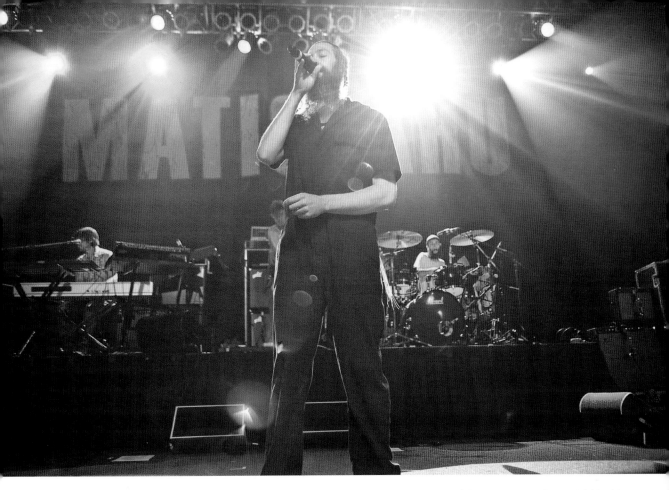

1.10 *The relatively wide 28mm setting on a full-frame camera allows you to fit quit a bit of the scene in your shot, as I did in this shot of Matisyahu. Taken with a Nikon D700 with Nikon 28-70mm f/2.8D at 28mm; ISO 3200 for 1/60 sec. at f/2.8.*

For the money, this is going to be the most versatile lens on your camera. Since most small to mid-sized venues have stages that are only from three to five feet tall and you'll be only a few feet from the performer, using the wider settings allows you to get creative angles or get a few of the band members in the shot. The middle range gets you great three-quarter normal shots, while the short telephoto allows you to isolate the subject with a close-up.

Your mid-range lens offers you the most bang-for-the-buck, as the saying goes. If you plan on making concert photography your profession or you plan on doing it even at a semi-pro level, I recommend making this lens one of your best investments. As I mentioned before, your lenses are more likely to outlive your camera bodies several times over, and since this will be the lens you use for most of your shots, investing in a quality lens is your best bet.

1.11 *Zooming the lens in to 70mm gets a nice intimate "portrait," as I did here with Benjamin Kowalewicz, the singer of Billy Talent. Taken with a Nikon D700 with Nikon 28-70mm f/2.8D to 70mm; ISO 250 for 1/125 sec. at f/2.8.*

Telephoto Lenses

Telephoto lenses have long focal lengths and act like a telescope to really pull your subject in and allow you to fill the frame with your subject even though you may be quite far away. The typical range for a fast telephoto zoom is 70-200mm. There are telephoto zooms made specifically for crop sensor cameras that cover the 55-200mm range, but most of these are variable aperture lenses. Lenses longer than 200mm are usually prime lenses. To make some of these longer lenses more affordable and portable, oftentimes they are offered with a fixed f/4 aperture.

The 70-200mm f/2.8 zoom will probably be your second most used lens. These lenses can be quite expensive, especially if you buy the camera manufacturer's pro lens that has image stabilization and all the bells and whistles. Fortunately, there are a few third-party manufacturers that also make telephoto lenses in this focal range. Although they aren't quite the same build quality as a manufacturer's lens, they are still high-quality lenses.

Personally, I don't bring my telephoto lens to most venues. I prefer to travel light, and I find the long range unnecessary in most small to mid-size venues. On the other hand, most of the other photographers I work with carry one with them at every shoot.

There are some reasons why photographers choose to bring these longer lenses even to smaller venues. Oftentimes the front of the stage gets crowded with other photographers using wider settings. Using a telephoto allows you to stand back away from the crowd and get your shots without being jostled about. Another good thing about shooting from further back is that the perspective you get can be better. Shooting from afar allows you to get a straight-on perspective, which appears a little more normal than the "up the nose" shots you often get when shooting right from the edge of the stage.

When shooting large festivals such as Bonnaroo, Lollapalooza, or Austin City Limits, it's usually imperative that you bring along a telephoto lens. The main stages are usually ten to fifteen feet high in order to make the band visible to thousands of fans, so if you don't have a telephoto you're not going to get the shot.

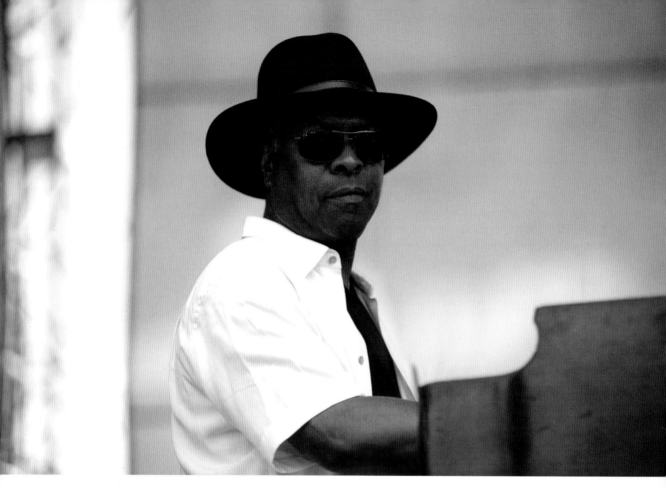

1.12 *I used a long lens to capture this close-up of Booker T at Bonnaroo. Taken with a Nikon D700 with Nikon 80-200mm f/2.8D at 155mm; ISO 200 for 1/320 sec. at f/2.8.*

Another time when you will need to use a long telephoto is when doing what's known as a *soundboard* shot. Sometimes top-billed performers and pop stars don't allow photographers access to a photo pit and make you shoot from an area near the where the sound engineer does his or her thing. The distance you may be shooting from is highly subjective and can be different even at the same venue, depending on how the stage crew has things set up. Sometimes even a 200mm lens on a crop sensor camera isn't even enough to pull you in close.

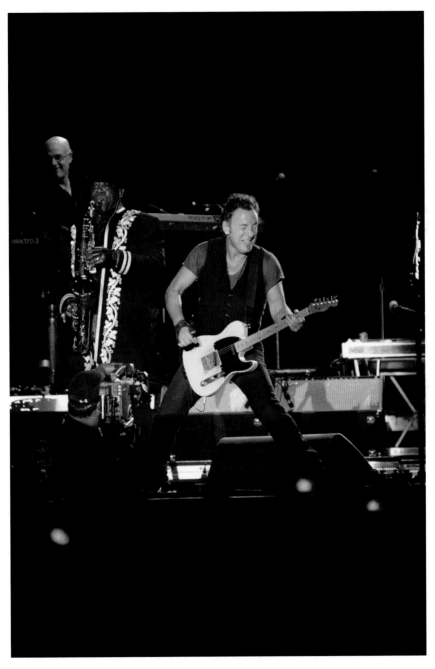

1.13 *Even with an 80-200mm lens on a crop sensor body I couldn't get a good close-up of The Boss. Taken with a Nikon D300s with Nikon 80-200mm f/2.8D at 200mm (300mm equiv.); ISO 2200 for 1/640 sec. at f/2.8.*

IS, VR, OIS, AND MORE . . .

Most camera and lens manufacturers these days have some sort of mechanical device that either shifts the lens elements or in some cases shifts the sensor inside the camera body to reduce the amount of apparent motion from camera shake. Camera shake is most evident at slower exposure times and is magnified exponentially as longer focal lengths are used. This technology goes by many different names: Canon uses the term Image Stabilization (IS); Nikon's terminology is Vibration Reduction (VR); Sigma uses Optical Stabilization (OS); and Tamron calls their technology Vibration Compensation (VC).

This technology helps you get steady images at longer exposure times than you would normally be able to achieve when handholding a camera. There is a rule of thumb that most photographers refer to when doing day-to-day photography. This rule is known as the *reciprocal rule*. The reciprocal rule states that your shutter speed setting should be at or near the reciprocal of the focal length of the lens you're using, so at 50mm your shutter speed should be about 1/50 (or the more common full stop setting of 1/60). What the reciprocal rule is designed to deal with is reducing blur from camera shake when handholding the camera. As focal length increases, the lens not only magnifies the scene but also any camera movement. This is a good guideline to follow for most photography. Stabilization technology allows you to handhold the camera at shutter speeds up to four times longer than would normally be recommended. Of course in the real world this is subjective, because not everyone's hand is as steady as the next person's.

There is no doubt that this technology *does* work, but only if the subject isn't moving at all or is moving slowly. Freezing a moving subject can *only* be done with a fast shutter speed. You will find that during most performances your subject is going to be moving around a lot, so this technology isn't an absolute necessity for concert photography even though it's usually done in low-light situations. Going with a lens that doesn't have image-stabilizing technology can save you quite a bit of money in the long run.

THE BASICS

This chapter will not only cover the basics as they apply in concert and live music photography, but also as they may sometimes apply in everyday photography. More advanced photographers may not need a primer on basics such as exposure, but this review can serve as a refresher course for those of you just getting back in the game or as a jumping-off point for the folks who are just entering the field for the first time. This chapter also covers some important things that some of you may have not had much experience with, such as using histograms for checking your exposure and using exposure compensation to get the exposures just right.

EXPOSURE

In photographic terms an exposure is the amount of light that is captured during a single shutter cycle. An exposure is made up of three different elements that are all interrelated—aperture, shutter speed, and ISO sensitivity. Although the numbering system of each of these is different, each change in a setting is known as a stop, and most cameras allow each setting to be changed in increments of 1/3 stops for more accurate control of exposure settings. As the value of one is changed the value of another must be changed proportionately to keep an equivalent exposure. For example, a typical exposure for taking a photo in a marginally lit theater is 1/15 at f/2.8 ISO 200. Trying to capture a moving musician at a shutter speed of 1/15 is going to make your photos rather blurry. To freeze a moving performer a shutter speed of about 1/125 is needed. The difference between 1/15 and 1/125 is 4 stops, so to get an equivalent exposure either the aperture needs to be opened up 4 stops or the ISO sensitivity needs to be increased by 4 stops. Of course, using an f/2.8 lens you're already wide open, so increasing the ISO sensitivity to 1600 is the only option. Therefore, 1/125 at f/2.8 ISO 1600 gets you the same amount of exposure as 1/15 at f/2.8 ISO 200.

The goal in any type of photography is to get the correct exposure, or just the right amount of light to the sensor so that the image recorded isn't too bright or too dark. In most other types of photography the goal is to keep detail in both the highlight and shadow areas. In concert photography this isn't

2.1 *Concert lighting is usually at the extreme edge of the dynamic range, going from deep black shadows to blown-out highlights often in the same image, such as in this photo of the Local Natives guitar player Ryan Hahn. Taken with a Nikon D700 with a Nikon Nikkor 28-70mm f/2.8D at 50mm; ISO 220 for 1/125 at f/2.8, spot metering −0.3EV.*

usually the case. The fact that most concerts are held in dimly lit areas with bright spotlights makes the *dynamic range* of the scene too wide for most sensors to capture. In photographic terms, dynamic range is the range between the brightest and darkest areas of an image.

What determines how much dynamic range your sensor can detect is the analog-to-digital converter, more commonly referred to as the A/D converter. Yes, that's right, even your digital image starts off as an analog signal before it's converted into image information. The rule of thumb is that the bit depth of the cameras A/D converter is the amount of dynamic range the camera can capture. Most cameras use anywhere between a 10- and a14-bit A/D converter, so on paper your camera sensor should be able to record a 10- to 14-stop difference in brightness. In actuality, however, around 5 to 9 stops is about the maximum tonal range you'll get from a typical camera. The human eye is an amazing "camera" and can view a dynamic range somewhere in the range of 24 stops!

What this means to the concert photographer is that in most cases there is no way to capture the complete tonal range of a typical concert scene. You as the photographer must decide what is more important, the shadow detail or the highlight detail, and adjust your exposure accordingly to capture one or the other.

2.2 *In this shot of James Hetfield of Metallica I exposed for shadow detail, since the light on him was relatively low. Since I was maxed out on my ISO setting, I used an unusually slow shutter speed but still managed to get a sharp shot. Keep an eye on your settings, because you may be maxed out and have to adjust on the fly. Taken with a Nikon D700 with a Nikon Nikkor 28-70mm f/2.8D at 50mm; ISO 3200 for 1/30 at f/2.8, spot metering.*

2.3 *This shot was taken just seconds after the photo in figure 2.2. As the spotlight shown on James Hetfield I changed the exposure and shot for the highlight detail. Taken with a Nikon D700 with a Nikon 28-70mm f/2.8D at 40mm; ISO 1800 for 1/200 at ƒ/2.8, spot metering.*

Shutter Speed

The shutter speed quite simply is the amount of time that your sensor is exposed to light. Most cameras have the ability to control the shutter speed from a very slow 30 seconds to a lightning fast 1/8000 of a second, and they are usually able to be set in 1/3 stops. Your most commonly used shutter speeds are fractions of a second, although on most cameras the shutter speed number is shown as a whole number, for example 1/125 of a second appears in the viewfinder as 125. When shutter speeds get down to 1 second or longer, most cameras indicate this by adding two hash marks after the number, so 8 seconds appears as 8″.

The shutter speed setting is used to control how motion is displayed in your photograph. Faster shutter speeds (1/125–1/8000) freeze motion. Slower shutter speeds (30 sec. to 1/15) allow the motion to be blurred. Shutter speeds in the mid-range (1/30–1/60) can go either way, depending on the motion of the subject: fast moving subjects tend to get a little motion blur, while slow subjects tend to be a little sharper.

For the purposes of concert and live music photography, sticking with a faster shutter speed is advisable; generally around 1/125 will do for most applications using a wide-angle to short telephoto setting. When using longer telephoto lenses, you should refer to the reciprocal rule discussed in Chapter 1 to determine your shutter speed settings.

At times you may want to show some movement in your shot to capture a feeling of action. In this case using a slower shutter speed is what you'd want to use. The idea here is not to make *everything* in the image blurry, but to highlight one aspect. One of the most commonly seen effects is a guitar player who is standing relatively still but his picking/strumming hand is moving fast, this gives you a nice sharp image of the guitarist with his hands a blur, giving your still image a feeling of motion and action.

Generally, I don't often use a slow shutter speed until I'm sure that I've gotten all the shots that I need. Then, if I have time, I will sometimes open up and experiment with slow shutter speeds or other tricks.

2.4 *Using a fast shutter speed allowed me to freeze the motion of Zach Blair, the guitar player of Rise Against as he jumped.*
Taken with a Nikon D700 with a Nikon Nikkor 28-70mm f/2.8D at 52mm; ISO 1400 for 1/200 at f/2.8, spot metering.

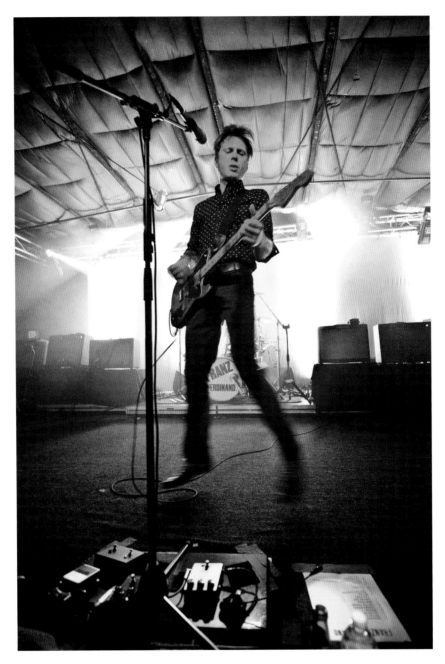

2.5 *Using a slow shutter speed added some motion blur to this image, as the guitarist and singer for Franz Ferdinand, Alex Kapranos, did a quick jump. Taken with a Nikon D700 with a Nikon 14-24mm f/2.8G at 15mm; ISO 3200 for 1/30 at f/2.8, spot metering.*

Aperture

The *aperture*, also known as the *f/stop* (these two terms are interchangeable), is the lens opening. All lenses have a diaphragm that functions exactly like the iris of your eye: it opens wider to let more light in through the lens, and closes down to reduce the amount of light coming in. In the vernacular of a photographer, *opening up* refers to making the aperture wider, and *stopping down* refers to making the aperture smaller.

Apertures are referred to by f/numbers. Smaller numbers denote a wide or large opening, and larger numbers denote a narrow or small opening. To some, especially beginning photographers, this seems completely counterintuitive and can lead to some confusion. It only begins to make sense when explained in more detail.

The first thing you should know is that f/numbers are actually ratios, which translate into fractions. The number of the f/stop is determined by dividing the diameter of the lens opening by the focal length of the lens. The easiest way to think about it is to put a one on top of the f/number and make a fraction out of it. As an example let's use a Zeiss 50mm f/2 lens; take the aperture number of f/2 and turn it into a fraction with 1 as the numerator, which comes out to 1/2. This indicates that the aperture opening is half the diameter of the focal length, which equals 25mm. At f/4 the diameter of the aperture diaphragm is 12.5mm. So in effect, 1/2 or f/2 is a larger number than is 1/16 or f/16. This is why the smaller numbers are larger openings and the larger numbers are smaller openings.

The most common f/numbers (in one-stop increments) are: 1.4, 2, 2.8, 4, 5.6, 8, 11, 16, and 22. At first glance these look like a random array of numbers, but looking a little closer you see that every other number is a multiple of 2. Although not obvious, if you break it down even further you will discover that each number is actually a factor of 1.4: 1.4 multiplied by 1.4 is 1.96 (rounded up to 2) ; 2.8 multiplied by 1.4 is 3.92 (rounded up to 4); 4 times 1.4 is 5.6.; and so on.

In photography the aperture or f/stop is a double-edged sword, so to speak, meaning that the aperture has two functions that are not mutually exclusive but are tied together. Wide apertures not only let in more light, but they also decrease the depth of field so that the background is out of focus. On the opposite end, using a smaller aperture increases the depth of field, resulting in an image that has a background that is in sharp focus.

About 90% of the time when shooting concerts you will be shooting *wide open*, which is photographer slang for shooting at the maximum aperture. The reason is twofold. The first and main reason has been mentioned before: concerts and live music venues are generally pretty dark, and you need all the light you can get. Secondly, the shallow depth of field helps to blur out some of the distracting features that are likely to be on the stage behind your subject. Depth of field is covered in a little more depth in the sidebar.

DEPTH OF FIELD

The technical definition of depth of field, often referred to as DoF, is the distance range in a photograph in which all portions of the image are acceptably sharp. By focusing the lens on a certain point, everything in the image on the same horizontal plane is in focus as well. Everything in front of and behind that point (known as the plane of focus) is technically not in focus, but our vision isn't keen enough to perceive the minor amount of blurring that occurs and it still appears to our eyes as sharp. This is what photographers call the zone of acceptable sharpness, or more commonly depth of field.

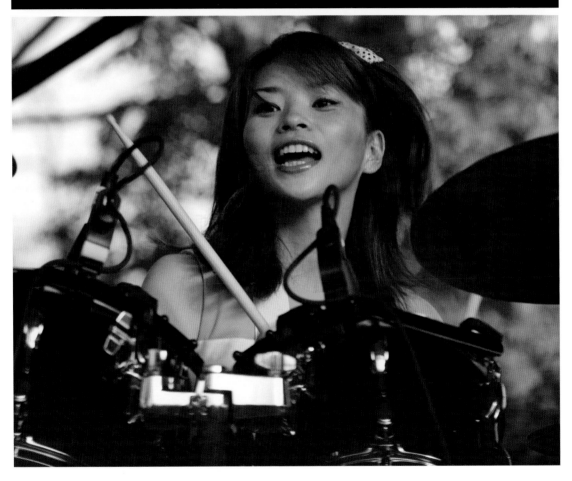

2.6 *This shot of drummer Etsuko Nakanishi from the band Shonen Knife has a very shallow depth of field; notice that the background is an indistinct blur. Taken with a Nikon D300s with a Nikon 80-200mm f/2.8D at 135mm (202mm equiv.); ISO 200 for 1/250 at f4.5, spot metering.*

The zone of acceptable sharpness is based upon a concept known as *the circle of confusion*. The circle of confusion is the largest blurred circle that appears to the human eye to be acceptably sharp. Factors that contribute to the size of the circle of confusion are visual acuity, viewing distance, and the size of the image. A circle of confusion is formed when light passes through the body and opening of a lens. Changing the size of the circle of confusion is as simple as opening up or stopping down the aperture. Open up the aperture and you get a large circle of confusion, which translates into an image with a shallow depth of field and more areas out of focus. Stopping down the aperture creates smaller circles of confusion, which results in the depth of field being increased and more of the image being in focus.

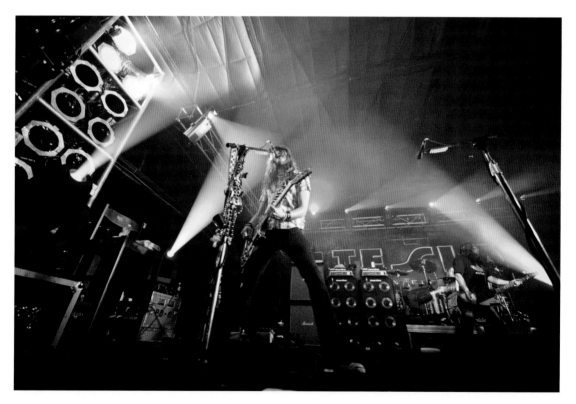

2.7 *This wide-angle shot of Tesla has a deep depth of field, everything from foreground to background is in focus. Taken with a Nikon D700 with a Nikon 14-24mm f/2.8G at 14mm; ISO 2000 for 1/200 at f/2.8, spot metering.*

DoF is mainly determined by aperture size but is also greatly influenced by subject distance. The closer you focus on your subject, the shallower the depth of field is at any given aperture. For example, focusing on a person 12 feet away

using an aperture of f/16 results in a photo where everything is sharp from fore-ground to background; but focus on a smaller subject just 12 inches away at f/16 and you will have a shallow depth of field.

A third element in DoF is focal length. Shorter focal lengths have deeper depth of field at the same focus distance as longer focal length lenses.

ISO Sensitivity

The third equation in the exposure triumvirate is ISO sensitivity, or what used to be commonly known as *film speed*. ISO stands for International Organization for Standardization. Even cleverer is the fact that the term *iso* is Greek for *equal*. The ISO standard makes sure that the sensitivity of the sensor is equal across all plat-forms, so that ISO 100 yields the same exposure no matter what camera you are using or even whether it's film or digital.

ISO sensitivity controls how much the camera hardware amplifies the signal from the sensor, but for all practical purposes and for simplicity's sake, for our needs as photographers the ISO determines how sensitive the camera sensor is to light. Higher numbers mean that the sensor needs less light to make a proper exposure. Most cameras have base ISO settings that range from ISO 100 to ISO 6400. Standard ISO settings are 100, 200, 400, 800, 1600, 3200, and 6400, in one-stop intervals. Each increase doubles the sensor's sensitivity to light. As with shut-ter speed and aperture, most cameras allow you to change the ISO settings in 1/3 stops to allow you to finetune your exposure settings.

Some cameras have expanded settings that allow you to go even higher, to an ISO setting equivalent to ISO 25600 in the case of the Nikon D700 and D3. These expanded settings are exceptionally noisy, and I don't recommend using them except in extreme situations.

As you increase the ISO sensitivity you amplify the signal from the sen-sor. Unfortunately, as you amplify the analog signal from the sensor, you amplify some unwanted signals as well, resulting in *noise* or random-colored dots in your images.

This type of noise is known has *high ISO noise*, which is caused, as indicated earlier, by amplifying the signal from the sensor. (Another type of noise is *thermal noise*, which is the result of long exposures that aren't a real issue in concert pho-tography.) Background electrical noise exists in all electronic devices. Generally the background noise is very small and mostly unnoticeable, but when amplify-ing the signal from your sensor you also amplify the background electrical noise, which shows up as noise in your images.

Tip: Even when shooting a concert in the daytime with plenty of light, shoot wide open to take advantage of shallow depth of field. Not only does it look more artistic, it also isolates the performer and separates them from the background.

2.8 *An extreme example of digital noise. Taken with a Nikon D5100 with a Sigma 17-70mm f/2.8-4 at 50mm; ISO 25600 for 1/200 at f/2.8, center-weighted metering metering.*

Digital noise is comprised of two elements, chrominance and luminance. Chrominance refers to the color of the specks (which are most commonly red and blue), and luminance refers to the sizes and shapes of the individual specks of noise (all of which increases as the sensitivity is increased).

AUTO-ISO

Surprisingly, one of the favorite features of my camera to use when shooting live music is Auto-ISO. Although some old-timers and manual exposure hardliners may scoff at using an automatic feature (which many look upon as a crutch for amateurs), I am of the mindset that I will take advantage of any feature that allows me to focus more on composition and less on fiddling with settings.

One great advantage to using the Auto-ISO setting is that you increase the number of images you get with a lower level of noise. Back before cameras were equipped with Auto-ISO, generally you would get into the photo pit, set your ISO to about 1600, and then adjust the shutter speed and aperture accordingly. All of the images taken had the same relatively high noise level. At most concerts, the lights are flashing and pulsating, going from light to dark and back again. Using Auto-ISO, the camera's metering system recognizes when the lights are bright and automatically reduces the sensitivity for me, resulting in more clean images than I would have gotten by setting the ISO to 1600 and forgetting it.

If your camera has an Auto-ISO setting I highly recommend giving it a try. It's a great tool that will increase your chances of getting more useable images. As I always say, if the technology is there, use it!

EXPOSURE MODES

Exposure modes determine how the exposure settings, specifically the shutter speed and aperture, are selected. The camera can select all or some of the settings, or you can set the exposure manually.

Each camera manufacturer uses slightly different terms to refer to their exposure modes, but for all practical purposes they all work the same. There are four main exposure modes: Program (Auto), Aperture Priority, Shutter Priority, and Manual. Some cameras, especially the more entry-level models, offer what are commonly called "scene modes." These modes are specifically designed for certain types of photos, and the camera controls all of the settings, often right down to the ISO setting. Scene modes will not be covered here, because you should *never* shoot a concert using a scene mode. That being said, each of the four major exposure modes can be used quite well for concert and live music photography.

Programmed Auto / Program Auto

Programmed Auto (Nikon) or Program Auto (Canon, Sony, etc.) is an automatic exposure mode in which the camera determines both the shutter speed and the aperture setting. This mode is usually designated P on the camera mode dial, and it shouldn't be confused with the fully automatic mode that's usually shown as a green camera or green square on the mode dial (*never use the green mode!*).

When using P mode the camera chooses the settings by taking in account the focal length of the lens and the available light. When the light is fairly dim, the camera chooses a shutter speed that is just a little faster than the shutter speed recommended by the reciprocal rule, and it chooses a wide aperture. As the light is increased, the camera begins to decrease the light by alternately making the shutter speed faster and stopping down the lens.

Program mode is an auto mode with a twist. Although the camera chooses the settings, you can quickly alter them on the fly. This is called Flexible Program in Nikon terminology and Program Shift on most other camera systems. If you notice that the settings the camera chooses isn't necessarily what you're looking for, then you can rotate a dial and change the settings.

This isn't a setting I use very often, but I have used it from time to time with great success. That being said, the *only* time I use P mode is in conjunction with the Auto-ISO feature. My Nikon cameras allow me to set a minimum shutter speed to which Programmed Auto adheres as long as there is ample light. Generally I set the minimum shutter speed to 1/125 or use the reciprocal rule for longer lenses. Not all cameras have this minimum shutter speed option, so you may want to check your camera manual.

This mode is best utilized in circumstances where there is adequate lighting and a relatively uncluttered background. If you're not concerned about controlling depth of field, and you have enough light to keep a fast enough shutter speed to freeze the subject movement, then go ahead and pop it into P mode. This mode can let you concentrate more on framing and composition.

Aperture Priority / Av

Aperture Priority or Av / Aperture Value (depending on your camera system) is a semiautomatic mode. In this mode you select the aperture value and the camera determines the shutter speed. This isn't a mode you want to use in a low-light situation, because getting a fast shutter speed can be a crapshoot, and if you need to freeze the subject, you may not get a fast enough shutter speed. This is a very good mode to use when shooting outdoor concerts where the light may be changing intermittently, such as on a partly cloudy day. If you have enough light

that a slow shutter speed isn't going to be an issue, you can use Aperture Priority to control your depth of field.

Shutter Priority / Tv

Shutter Priority or Tv / Time Value is another semiautomatic mode. When using this setting you select the shutter speed and the camera determines the proper aperture setting to use to get a correct exposure. This is a good mode to use in a relatively dark setting with constant lighting. This ensures that you get the shutter speed that you're after. Since it's dark, your aperture is most likely to be wide open. This is also a good mode to use if you want to experiment with changing the shutter speed for motion blur effects.

Manual Exposure / M

Manual exposure is exactly what it sounds like. You, the photographer, set both the shutter speed and the aperture. This is the preferred method of most concert photographers. This allows you complete control of all your settings. The key to using this mode properly is keeping your eye on your camera's exposure meter, and knowing which metering modes to use under particular circumstances. Metering modes are covered in the next section.

When using Manual exposure I usually like to keep my camera set to Auto-ISO. This allows me one less setting to worry about. See the sidebar on Auto-ISO for more information on using the Auto-ISO setting.

METERING MODES

Metering modes are a very important feature of any camera system. These modes determine exactly how the camera determines what the proper exposure is. The metering modes use different ways of evaluating light coming from the scene, and they use these measurements in conjunction with the exposure modes to determine what settings are proper for the given situation.

Each camera system has its own proprietary names for its particular metering system, but most of them function pretty much on the same principles.

Matrix / Evaluative / Multi-Segment

This metering mode breaks down the scene into multiple areas or segments, measures the amount of light coming from each segment, determines what kind of photograph is being taken from an internal database of image data in the camera's firmware, and determines what the proper exposure should be. The number of segments differs depending on the camera manufacturer, the camera model, and in some cases even the type of lens being used.

Some metering systems also take into consideration color, contrast, brightness, and subject distance, which often helps not only with exposure calculations but with focus tracking as well.

Although this type of metering is very useful in most everyday photographic situations, for concert and live music applications you will find that you won't be using this metering mode very often. This mode is utilized best when shooting outdoor events during the day.

Center-Weighted / Partial

Center-weighted metering is exactly what it sounds like; the camera's metering system bases the exposure mostly from the center of the frame. Most cameras take into account 70 to 75% of the exposure from the center and 25 to 30% from the edges. In concert photography, especially at the larger venues with more complex lighting, oftentimes there will be a lot of bright lights at the edges of the frame, which can fool Matrix/Evaluative meters. Using center-weighted metering yields a more consistent exposure reading because the bright lights on the edges aren't being taken into account as much. The metering system is basing most of the exposure readings at the center of the frame where the subject is most likely to be placed.

This metering mode is best used when the lighting is fairly consistent, such as at smaller venues or clubs that have adequate but not elaborate lighting set-ups, such as standard spotlights. Another time when this metering mode is useful is when shooting outdoor events when the sun is starting to set to dusk. This is usually when you can start to notice the stage lighting, but the overall daylight is still the main source of illumination.

> *Some cameras allow you to adjust the size of the center-weighted area for more accurate control of the exposure.*

Spot

Spot metering does just that: it takes a tiny spot and bases the exposure calculations from that one spot, ignoring the rest of the lighting from the entire scene. Most camera spot meters read anywhere from 2 to 5% of the scene. For most modern camera systems the spot meter is tied to the active focus point, which is very convenient. This allows you to meter and focus at the same time, rather than taking a light meter reading, locking the exposure, then recomposing for the focus.

Tip: Matrix / Evaluative metering can be used when the subject is wearing white against a black background. This mode tends to even out the exposure without losing much detail in the white, while the other modes tend to under- or overexpose.

This is by far the most used metering mode in concert and live music photography, especially in the larger venues with the most elaborate lighting setups. The flashing, moving, pulsating lights wreak havoc with the other metering modes. Spot metering ensures that the point of focus is exposed properly, ignoring the rest of the scene.

FINE-TUNING YOUR EXPOSURE

Oftentimes, since the lighting is so extreme, you can't rely on your camera's meter to be 100% accurate. You need to actively evaluate your images to be sure that you're keeping image detail where you need it. Losing shadow or highlight detail in the background isn't a big deal, but you do want to retain as much shadow and highlight detail as you can on your subject.

Using Histograms

By far the most valuable tool you have to evaluate your exposure is the histogram; unfortunately, the histogram is also one of the most widely misunderstood features of the camera. Almost all cameras have a feature that lets you view the histogram, and I urge you to use it.

A *histogram* is a graphic representation of the tonal values of your image. There are two types of histograms, *color* and *luminance*. The color histogram shows the tonal values of each color channel of the image and is separated into three histograms: red, green, and blue. The second type of histogram, which is the one that's most important for evaluating exposure, is the luminance histogram. The luminance histogram shows the brightness or luminosity of the image, which is what we perceive as the exposure.

Since a histogram is just a factual representation of the luminosity values of your image there is no *proper* histogram; however, you should try to set your exposure so that the tones are spread across the whole graph. In general everyday photography, you usually want to watch for spikes at the extreme left and right of the graph, which indicate that there are highlights and/or shadows that are clipping, but in concert photography this is usually the norm, due to the extreme lighting conditions you are usually faced with.

Take a look at figures 2.9a and 2.9b. This is what is known as a *high key* image, meaning that it is very bright. Looking at the histogram you see that although the image is bright, the tones are distributed throughout the whole graph. This is more or less what a high key histogram should look like. Had there been a brighter background, the histogram would be weighted more to the right, but the tones would still pan out evenly.

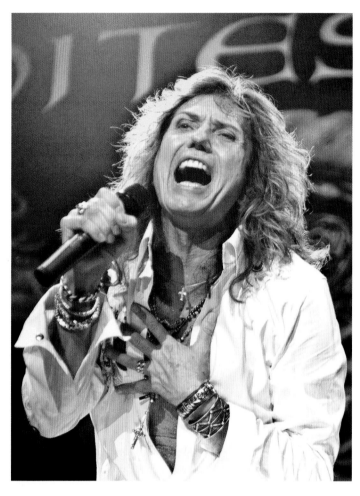

2.9a *This high key shot of David Coverdale of White Snake was taken with a Nikon D700 with a Nikon 28-70mm f/2.8D at 60mm; ISO 1600 for 1/200 at f/2.8, spot metering.*

2.9b *This histogram indicates a good exposure for a high key image.*

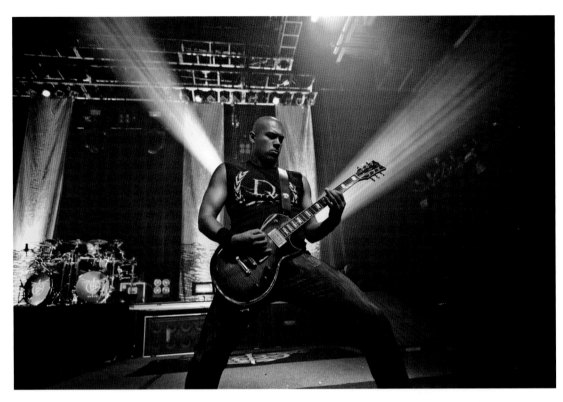

2.10a *This low key shot of Lamb of God temporary guitarist, Doc Coyle was taken with a Nikon D700 with a Nikon 14-24mm f/2.8G at 24mm; ISO 3200 for 1/60 at f/2.8, spot metering.*

2.10b *This histogram indicates a good exposure for a low key image.*

Now take a look at figures 2.10a and 2.10b. This is a *low key* image, meaning that it's mostly on the dark side, although there are bright points in the shot. Notice that the histogram is the opposite of the previous image: most of the tones are on the left side, indicating the image is dark, but the tones taper across the graph, showing that the image has a full tonal range.

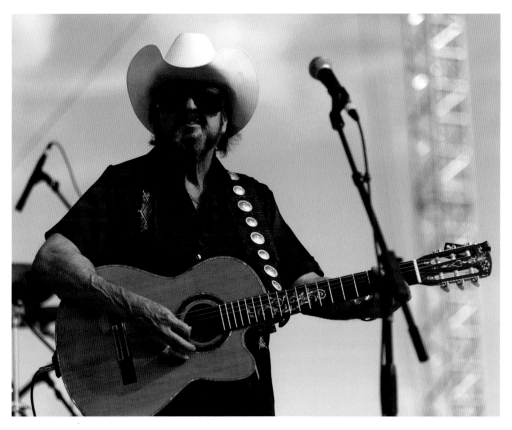

2.11a *This daylight shot of country singer and songwriter Johnny Bush was taken with a Nikon D700 with a Nikon 80-200mm f/2.8D at 125mm; ISO 200 for 1/3200 at f/2.8, matrix metering –0.3EV.*

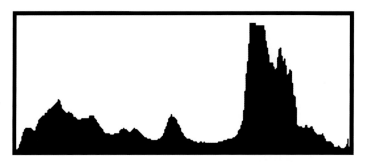

2.11b *This histogram indicates a good neutral exposure.*

Now figures 2.11a and 2.11b show a typical outdoor concert shot. There are neither extreme highlights nor extreme shadows. Notice that again the tones are distributed evenly across the histogram graph, but the tones taper off at each

end, which indicates that there are no blown highlights or blocked up shadows and that this is a good exposure that retains both highlight and shadow detail as well as good tonal range.

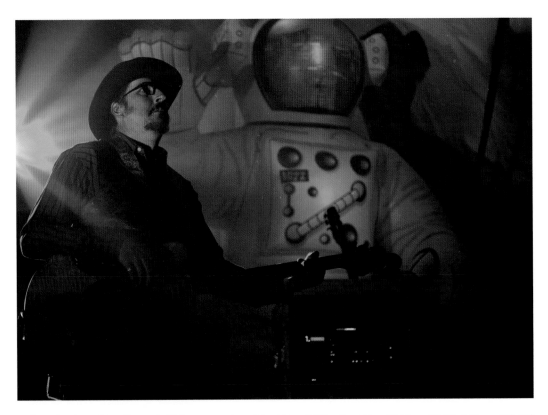

2.12a *This shot of Les Claypool of Primus was taken with a Nikon D700 with a Nikon 28-70mm f/2.8D at 50mm; ISO 560 for 1/200 at f/2.8, spot metering –0.3EV.*

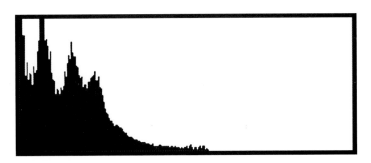

2.12b *This histogram indicates an underexposed image.*

Figures 2.12a and 2.12b show an underexposure. Just as I locked exposure settings and pressed the shutter release button, the front spotlight turned off, resulting in an underexposed image. Notice in the histogram that the graph is bunched up to the left side and tapers off to about the middle. This indicates that all of the tones in this image are in the shadows and mid-tones and that there are no highlights in this image at all. If I were going for a silhouette effect, this type of histogram would be acceptable, but for most shots you don't want your image to have this type of histogram.

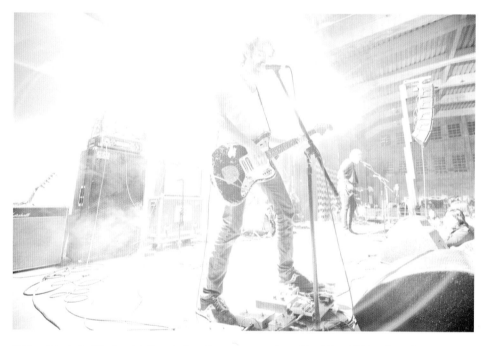

2.13a *This shot of the band A Place to Bury Strangers was taken with a Nikon D700 with a Nikon 14-24mm f/2.8G at 14mm; ISO 6400 for 1/100 at f/2.8, spot metering.*

2.13b *This histogram indicates an overexposed image.*

The example in figures 2.13a and 2.13b are on the complete opposite spectrum of the previous figures. Just as I had locked down my exposure and released the shutter a strobe went off, severely overexposing the image. The histogram shows all of the tones to the highlight side and no shadows at all. Sometimes an overexposure like this can look pretty cool, but once again, this is a situation you generally want to avoid.

EXPOSURE COMPENSATION

When using Programmed Auto or any of the semi-auto modes (Shutter Priority or Aperture Priority), you may notice that your camera is consistently metering over or under, causing your exposure to be off. You can easily fix this by applying exposure compensation. Almost all cameras have this feature that lets you adjust the exposure slightly. Usually this feature is easily accessible so you can adjust it quickly. I often set my exposure compensation to –0.3EV to tone down the highlights a bit

AUTOFOCUS

Autofocus is a pretty important feature in your camera. Today's digital SLR cameras aren't really great for determining if the scene is in focus while manually focusing, especially in low-light situations. There are a few things that can help, such as focus lock indicators and digital rangefinders, but these are only marginally helpful. In the past, manual focus cameras had viewfinders, such as split-view and microprisms, that made manual focusing much easier.

These days it's much quicker and makes more sense to use your camera's highly sophisticated autofocus modules. Each camera has a set number of focus points, anywhere from 3 points in entry-level cameras and up to 51 points in Nikon's pro cameras (Canon pro cameras sport 45 points). Of course, the more AF points you have the easier it is to get an accurate focus without having to lock focus and recompose, which can cause you to lose a shot if the performer is moving quickly.

AF works by detecting contrast in the scene using focus sensors, which pertain to each AF point. There are two types of AF sensors: plus-type sensors and minus-type sensors. Each of these AF sensors are shaped exactly as they're described. Each type of sensor has its strengths and weaknesses.

Plus-type sensors can detect contrast running in two directions, horizontally or vertically. Minus-type sensors can only read contrast in one direction, which is of course determined by the camera orientation. Plus-type sensors are the more

accurate type of sensor, but they're a little slower to work as compared to minus-type sensors.

Different cameras employ different numbers of each type of sensor. Generally, high-end cameras have more plus-type AF sensors than lower-end models. Some entry-level cameras only employ a plus-type sensor in the center focus point, and even then it may only act as a plus-type sensor if a f/2.8 or faster lens is attached to the camera.

HOW AF WORKS

Most cameras use an autofocus module that is based on a principle called SIR-TTL, or Secondary Image Registration–Through The Lens, more commonly referred to as Phase Detection Autofocus.

Simplified, how this works is the camera uses a beam-splitter to redirect some of the light coming through the lens to two optical prisms, which projects two exact but separate images to the camera's AF sensor. The sensor determines whether these two images are in focus, measuring the contrast, or more specifically detecting whether the images are in phase, hence the term Phase Detection. Lenses with wider apertures make it easier for the camera's AF module to determine whether the images are in phase, so they are usually faster to focus than slower lenses such as a kit lens.

Cameras that have a Live View feature use a different form of focusing called Contrast Detection. The method reads contrast information directly at the pixel level from the sensor. This method is much slower and is how point-and-shoot cameras operate. I encourage you not to use the Live View method to shoot concerts, as it is strictly for amateurs and often encourages photographers to lift their cameras above their heads, which blocks the view of other photographers and the fans.

AF-AREA MODES

These modes determine which AF point is chosen and how. Some cameras may have three or more AF Area modes, but all cameras have at least some version of these two. A lot of cameras, especially entry-level cameras, have Auto Area AF modes, but these modes are just about useless in a concert situation because of the immense amount going on in the scene—multiple subjects moving, brightly colored flash lights, and busy backgrounds all tend to confound the Auto Area AF modes, so these should be avoided at all cost.

SINGLE POINT AF

This is the option that should be used most of the time. This allows you, the photographer, complete control of where the focus point is at all times, so you

make the decision where the camera should focus (and where it should meter when spot metering). Using your camera's multi-selector and commander wheel allows you to scroll through the focus points, placing them exactly where they should be.

Dynamic Area / Predictive AF

Most cameras have this sort of automated AF-Area, where you select the AF point and the camera tracks the subject instantly if it moves from the selected AF point. Using this mode can be relatively unpredictable unless you're shooting in a well-lit venue or in the daytime. Even then, when shooting at a shallow depth of field this can cause your focus to be slightly off. I recommend only using this in bright lighting and when shooting at an aperture of f/5.6 or smaller.

Continuous / AI Servo

Continuous AF (AF-C) in Nikon terminology or AI Servo in Canon terms is a focus mode that allows the camera to continuously focus on the subject while it is moving as long as the shutter is half-pressed. This is the focus mode you will want to use about 95% of the time, since your subjects are generally going to be moving around the stage quite a bit.

Single / One Shot

In Nikon terminology Single AF (AF-S) or One Shot in Canon dialect is a focus mode that locks focus once focus has been achieved as long as the shutter button is half pressed. Releasing the shutter release button reactivates the AF, and once it locks, again it will remain locked as long as the shutter release is half pressed. I reserve this mode only for seated and relatively static performers or when shooting backstage portraits.

RAW VS. JPEG

Although in some areas of photography, shooting JPEGs can be beneficial for allowing quicker burst rates, less post-processing time (provided you nail the exposure), and smaller file sizes, most professionals agree that when dealing with low-light exposures, unpredictable lighting, and mixed-color light sources, shooting RAW is your best bet.

Without going into the boring details about compression algorithms and quantizing coefficients and Discrete Cosine Transforms, JPEGs are compressed files. Once the shutter is released and the camera's image processing engine is finished processing the image data, any unneeded data is thrown away, leaving

you with an 8-bit file in which the image data has been fixed. This allows for a much smaller file, especially when the file is compressed. Of course, some adjustments can be made using editing software, but with the limited amount of data in the file, more radical changes can cause unwanted artifacts in your image file such as posterization and banding, or fringing. This is evidenced by mottled colors rather than a smooth gradation in color tones.

Each camera manufacturer has its own proprietary image processing system or engine, as they are sometimes referred to. Nikon has EXPEED, Canon has Digic, Sony has Bionz, etc.

For the most flexibility in post-processing images, you need to shoot RAW. Each manufacturer has its own type of RAW file, .NEF for Nikon, .CRW for Canon, and so forth. For all practical purposes, these files are the same: RAW files contain all of the image data that was captured at the time the exposure was made and are usually 12- or 14-bit files, depending on the camera.

When the RAW file is recorded, all of the same settings that would apply to a JPEG are saved as well: white balance, sharpening, noise reduction, saturation, etc., but instead of being fixed as in the JPEG, this image information is just tagged in the file. Using a RAW converter such as Adobe Camera RAW (ACR) you can change these image tags without losing any of the actual image data.

Some camera models actually compress RAW files. These usually use a lossless compression, but some models use a lossy compression that does discard some image data. This compression is minimal compared to JPEG compression and should not affect the image quality.

The biggest advantage in using a RAW file is bit depth. As I mentioned before JPEGs are 8-bit files and RAW files are usually 12- or 14-bit. Simplified, what bit-depth breaks down into is how many separate colors your camera has the ability to capture and store in the file. An 8-bit file can record up to 256 luminosity values for each separate color channel in the file: Red, Green, and Blue. Broken down further to the pixel level, this theoretically allows your camera's sensor to record more than 16 million different colors. A 12- or 14-bit image has many, many more colors available—so many it's almost mind-boggling.

What this boils down to is that the more colors you are able to record in your image the smoother the color gradation you can achieve in your images. This is especially important in shadow areas, where you can often see posterization or banding caused by the camera's inability to smoothly go from darker to lighter tones because of the lack of image information in an 8-bit file. This can also be seen in areas of high color saturation, which often happens in concert photography due to the vivid colors of the lights that are often used.

I highly recommend shooting RAW for almost all photography, whether it be concerts or portraits. That being said, it *is* entirely possible to shoot concerts and live music using JPEGs and still get great images. Sometimes when shooting festivals I shoot in JPEG during the day when I have consistent even lighting. This saves me post-processing time by not having to convert the files to JPEG for transmitting to my agency.

WHITE BALANCE SETTINGS

As most of us know by now, not all light sources are the same color. The human brain can be put in any type of light source and will automatically figure out what is white and compensate for it. Our cameras only see what actually is there, so they must be adjusted to compensate for different light sources. Of course, most cameras have Auto white balance settings, which work reasonably well in most situations.

One of the main reasons I recommend shooting in RAW is the ability to adjust the white balance settings without any degradation to the image quality. When the white balance is fixed in a JPEG you can make some adjustments, but the quality can really suffer.

In most concerts at larger venues you will have dozens if not hundreds of lights. They will all be flashing different colors on and off. You really have no way to set a proper white balance, and that being said, oftentimes you don't even want the white balance to be proper or you'll kill the effect of the lighting on the tone of the scene.

I'm often asked what white balance setting I use, and my answer is invariably, Auto. When you've got lights flashing at different colors it's almost pointless and near impossible to determine what the proper white balance setting is going to be on the fly. And when shooting RAW you have the ability to change the white balance settings in your RAW converter. This is one of my favorite features of shooting RAW. In effect you can take an image and completely change the lighting scenario to fit your needs or tastes. You can become the lighting designer after the fact!

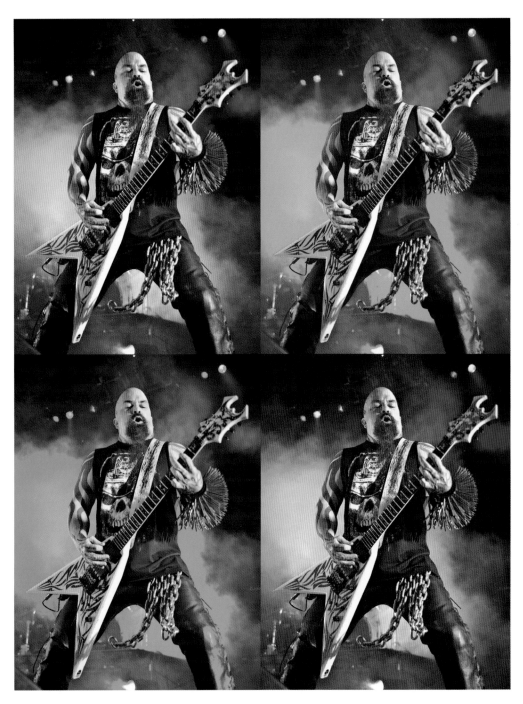

2.14 *This figure shows you how powerful the ability to change the white balance is when using a RAW converter. Taken with a Nikon D700 with a Nikon 28-70mm f/2.8 at 40mm; ISO 1400 for 1/400 at f/2.8, spot metering.*

Take a close look at figure 2.14; this is a composite of four of the exact same photo of Kerry King the guitar player for the metal band Slayer. See how drastically the lighting can be altered with a simple click of the white balance tool (also known as the eyedropper) in Adobe Camera RAW or Lightroom. On the top left I clicked the eyedropper on the smoke just behind him to the left. This resulted in the smoke becoming the neutral color, adding a blood red and orange hue to Kerry (which is quite fitting for Slayer). Moving over to the image on the top right, I clicked the eyedropper on the white part of the guitar. This turns the background blue while still leaving Kerry some nice shades of blood red. Moving down to the lower right-hand image, I clicked the eyedropper on the green-tinted floodlight at the bottom between his legs; this caused the image to shift to a magenta tone, since magenta is the opposite or complementary color of green. For the image on the bottom left corner, I again clicked the eyedropper on the white guitar, but then I shifted the tint slider over to green.

As you can see neither image is the *wrong* color for the shot. It's dependent on your taste, or sometimes even your mood can influence your images. Personally I prefer the one on the top left, because I find the blood-red color of the highlights on Kerry King very ominous, much like Slayer's brand of music.

Of course, you're not always going to be shooting in an arena with hundreds of multicolored lights. Oftentimes you'll be in a club with a single row of PAR can lights (PAR stands for Parabolic Aluminized Reflector). That may or may not be gelled for different colors. In situations like this where the lighting is not going to change I'll usually set a custom white balance so I can get a fairly consistent color, which makes mass color corrections easier. Another time I will occasionally set a custom white balance is when I'm shooting an outdoor concert in the daytime and the lighting is consistent.

I never use the camera presets, as I find that most venue lights don't come anywhere near to matching any of the presets, unless you happen to be shooting at the local American Legion hall under a dropped ceiling with fluorescent lights. Don't laugh—when I started shooting live music as a young teenager, oftentimes my friends and I would put together all-ages shows for our bands at venues like this because we were too young to play anywhere else! It was at venues like these that I cut my teeth (and ruined a lot of Kodak Tri-X film!).

UBS, BARS, AND
ALL VENUES

Clubs, bars, and small venues are the places where most concert and live music photographers get their start, the reason being that there are fewer restrictions since the performers are less likely to be famous. These are often the best places to catch bands on the way up and sometimes on their way down.

Unfortunately, these venues are typically the ones with the worst shooting conditions. The good news is that when you start out shooting in the worst conditions it only gets easier as you work your way up.

One of the biggest problems you are going to have when shooting in bars and small clubs is dealing with the crowd. About 99% of the time there isn't going to be a place for photographers to set up. The key is to get there early and stake out a spot at the front of the stage. The best spot isn't dead center but usually just to the left or right of center. Standing off to the left side a bit allows you to get a better angle, especially when the lead vocalist uses a mic stand. This way the mic isn't blocking the singer's face, and you can get a nice three-quarter side shot instead of straight ahead. Singers who don't use a stand are more apt to move around, so in this case placement isn't quite as important.

Even if you showed up early and staked out your spot, be courteous to the people behind you. If you're constantly blocking someone's vision with your camera, things can get out of hand quickly, especially in a bar scene where you're mixing alcohol with a situation that could be potentially volatile.

3.1 *I showed up early to get a front-and-center spot to see actress Juliette Lewis and her band the New Romantiques. This enabled me to get this in-your-face shot. Taken with a Nikon D700 with a Nikon 28-70mm f/2.8D at 40mm; ISO 2500 for 1/320 at f/2.8, spot metering.*

If you don't show up early enough to get a spot you may have to ease your way up to the front. In these types of situations being extremely friendly is the only way to go. When you get up to the front make it very clear that you will only be there for a few songs. Offering to share some pictures with them is the best way I've found to smooth out this type of situation. After two or three songs move. My rule of thumb is that I'll shoot two songs and move to another angle to shoot a third if I can.

Sometimes you will encounter a venue that has no stage or lighting; in a situation like this you will have to jump directly into the fray. This isn't for the photographer who's faint of heart or afraid of damaging his or her gear. This is what I call "Gonzo Photography," so named after Dr. Hunter S. Thompson's Gonzo Journalism in which the writer puts himself right in the middle of the story. In these types of venues you usually find punk rockers slam dancing, beer will be flying around, and you, the photographer, must get in there and get the images for better or worse.

In these types of situations I find it's handy to have an ultra-wide angle lens and a flash. This is about the only time that I advise using the "Hail Mary" technique of lifting the camera and shooting down on the band. Set the aperture relatively small, f/8-11, to ensure a deep depth of field (focusing is nearly impossible in this type of situation). Set the shutter speed slow for a shutter drag to capture some ambient light, and set the flash to TTL.

3.2 *This floor-level punk show featuring the Lower Class Brats was taken in a 600-square-foot club with no lighting at all. The place was packed from end to end; there were bottles, beer, elbows, and fists flying all around. Putting yourself in the danger zone is the only way to get these kinds of shots. I used the built-in flash to light the scene, which was too dark for an ambient exposure. Taken with a Nikon D700 using a Zenitar 16mm f/2.8 fisheye lens; ISO 450 for 1 sec. at f/11.*

LIGHTING

Most clubs, if they have lighting, use PAR lights. PAR stands for Parabolic Aluminized Reflector. Although these are the same types of lights that are used in the huge lighting arrays for major concerts, in bars they are usually fixed in a certain position and are a constant light source, meaning the brightness doesn't change.

Most often the lamps used in the PAR cans are standard tungsten spotlights, usually with colored gel filters to add ambience. Gel filters are most often primary colors: red, blue, and green. A lot of newer venues or venues that have recently upgraded their lights are going with LED lights, which are lower in energy consumption, run cooler, and have more highly saturated colors than gelled tungsten lights. I'll get into the specifics of LED lighting later in the chapter.

The main problem that photographers run into when shooting at the club level is clipping in the separate RGB channels, or in simpler terms, single channels being overexposed due to the high saturation. While this can also be a problem when shooting concerts on the big stage, since the lighting isn't constant in larger venues it's less of an issue.

Digital imaging sensors are more sensitive to red light, therefore the red channel is usually the first channel to clip.

To understand why primary colored lights are such a problem we need to look into the camera itself, or more specifically the sensor. Inherently, digital camera sensors are only capable of producing a monochrome image.
To produce a color image the sensor is overlaid with a filter possessing the three primary colors: red, green, and blue. These filters are laid out in what is known as a *Bayer array*, named after Eastman Kodak scientist Bryce E. Bayer, who invented it. The Bayer array is laid out in a specific pattern of red, green, and blue lenses. To more accurately represent human vision, which is more sensitive to green light, the filter patterns are made up of 25% red, 50% green, and 25% blue filters. Light falling on the sensor passes through the filter to the pixels on the sensor, and the color data from each pixel is then interpreted using some complex algorithms, which determine the colors and brightness of the scene giving you a color image.

3.3 *Bayer Filter array of a typical DSLR sensor.*

Why this is relevant in regards to concert lighting with single primary colors is because when you have one solid, highly saturated color, you are losing as much as 75% of the image data; 75% for reds, 50% for greens, and 75% for blues. This results in the channel being overwhelmed with data, resulting in overexposure and loss of detail in the highlight areas. This is exactly the same as overexposing an image in a normal lighting scenario, and it's dealt with in much the same way—by applying exposure compensation to the camera's normal exposure meter reading. How much exposure compensation to apply is highly dependent on the lights themselves, so a little experimentation is usually necessary. Generally, underexposing by one to two stops is advisable to retain some highlight detail.

3.4 *Underexposing two stops from my meter reading helped to keep detail in this shot of Rontrose Heathman of the Supersuckers. Taken with a Nikon D700 with a Nikon 28-70mm f/2.8D at 70mm; ISO 3200 for 1/250 at f/2.8.*

LED lights, unlike Tungsten lights, do not need gel filters to change the color of the lighting. An LED light is made up of smaller individual red, green, and blue lights. LED lights are more highly saturated than standard gelled tungsten lights. The LED can not only produce strong primary washes, but two of its colors can also be mixed to create other colors, such as red and blue for an intense purple, or green and red to create an orange wash.

3.5 *This image of Perry Farrell of Jane's Addiction was taken at a small nightclub during a solo performance. The highly saturated LED lights give this overly purple tone. Taken with a Nikon D700 with a Nikon 28-70mm f/2.8D at 65mm; ISO 3200 for 1/320 at f/2.8.*

Even with underexposing to reign in the highlights, the images may still be overly saturated. There are a couple of ways to deal with this. You can present the images as they are, or you can go for a black-and-white conversion. While I don't recommend using black-and-white conversion as a crutch, it can give you a little more diversity in the shoot, which is why I usually do a mix of color and black and white when faced with this type of shooting situation.

3.6 *I converted this image to black and white using Channel Mixer in Adobe Photoshop. Although the original image with the purple tone looked good, converting to black and white enhanced the image and added to the overall effect. Taken with a Nikon D700 with a Nikon 28-70mm f/2.8D at 65mm; ISO 3200 for 1/320 at f/2.8.*

Tip: Some cameras allow you to select a RAW recording option of 12- or 14-bit. Shooting at a higher bit-depth allows you to capture more subtleties in the color gradation and therefore retain more detail in your images.

LED lights can be programmed to change colors with minimal technical knowledge and don't require anybody to operate the lights, so oftentimes in clubs with LED lights you will have a constantly shifting color spectrum. On the bright side, no pun intended, the luminosity of the lights is fairly equal so you can have a relatively consistent exposure.

3.7 *This series of images of Dick Dale, the "King of the Surf Guitar," were taken seconds apart. The LED lights constantly cycle between red, green, and blue. All images were taken with a Nikon D700 with a Nikon 28-70mm f/2.8D at 28mm; ISO 3200 for 1/125 at f/2.8, spot metering.*

The good news about shooting in small clubs and bars is that the lighting, although it may be less than ideal, is at least consistent. This means you can set your exposure and leave it alone for the most part. One caveat is that you may need to change the exposure for individual members of the band, because they will likely have different amounts of light falling on them. You also want to pay close attention to performers if they move in and out of the light.

Shooting Manual exposure yields the most consistent results. Keep your shutter speed fast enough to freeze any motion of the performers—1/125 is generally a good place to start. If the performers are staying fairly still, you can try using a slower shutter speed. If they are a frenetic group, you may have to go faster than 1/125. Giving your images a quick review should tell you whether you need to speed up the shutter speed or not.

As mentioned earlier, most often the lighting in small clubs or bars is relatively dim, so most likely you will need to shoot your lens wide open. I usually do

3.8 *For this shot of local Austin rockers the Flesh Lights I used center-weighted metering as opposed to spot metering to get a more accurate reading of the light in the scene. Taken with a Nikon D700 with a Nikon 28-70mm f/2.8D at 28mm; ISO 3200 for 1/100 at f/2.8.*

not recommend using fast prime lenses because of the limitations they impose on composing, especially in small clubs or bars where you're likely to be packed in with the rest of the crowd without a lot of room for movement. However, if you have enough room and good access to the band, you may want to consider using fast primes such as a 35mm f/1.8 if the light is especially low.

ISO setting is highly dependent on the shutter speed you need to use. Since you will likely be shooting wide, set the ISO high enough to get the shutter speed you're after. In these types of situations the best course of action is to set your camera to Manual exposure, set your exposure values (1/125 at f/2.8 is a good place to start), and then adjust the ISO sensitivity according to your light meter readings. Remember that if the lighting is overly saturated you may need to underexpose by a stop or two.

> *When the stage lighting is consistent, selecting the center-weighted metering option will give a more accurate exposure reading for the scene.*

USING OFF-CAMERA FLASH

When shooting at venues that have single color primary lights, or at venues that don't have any lighting at all save for the house lights, sometimes it's necessary to bring your own light source, that is, a flash. This is something I usually only resort to when I'm hired to shoot a band's live performance and I have no alternative. First and foremost speak to the band and whoever is in charge of the venue before setting up and explain what you are trying to do. I've never come across anyone who has refused to let me set up my flashes, but it's always best to get clearance ahead of time.

Setup

To clarify, this isn't the straight ahead flash-on-the camera approach; using off-camera flash requires some planning. In essence you are using your flash to simulate stage lighting. The best placement for your off-camera flashes is up high, with the light aimed down at the performers. Not only does this provide the best direction for the light, but it also gets the flash out of the performer's line of sight. As a gigging guitar player I can tell you that having a flash repeatedly fired directly in your face is a very frustrating experience, to say the least.

My first approach to this is to attach the remote flashes directly to the *light bar*; this is where the PAR lights are attached. If there is no light bar, or for some reason I can't reach the light bar (no ladder), I use a light stand. Setting up one light stand at the far end of each side of the stage is the best placement, and the taller the stands the better. An 8-foot stand is nice, but a 10-foot stand works even better. A third option for off-camera flash is to have an assistant hold the flash for you. You can even work out a system where your assistant aims the flash at different band members.

3.9 *When photographing Justin Townes Earle playing on the indoor stage at Stubb's Bar-B-Q in Austin, I set up one flash on a light stand at stage left (photographer's right). I pointed the flash head straight up to avoid a harsh direct light. At stage right (photographer's left) I aimed the flash with a blue filter at the background to add some ambience. Taken with a Nikon D700 with a Nikon 80-200mm f/2.8D at 125mm; ISO 3200 for 1/25 at f/2.8, spot metering –0.3EV. I used PocketWizard transceivers to trigger the off-camera flashes. The output of the flashes were set manually.*

If you're feeling particularly creative and you have enough remote flashes, you can also set up background lights. One good position for a remote background light is on the floor behind the drummer with the flash head pointed straight up. This gives a nice fill light, adding to the overall brightness of the scene.

FILTERS AND GELS

To further emulate stage lighting you can add color filters to the remote flash. Most camera manufacturers have filter kits for their flashes, or you can buy gel filters at almost any camera shop and cut them to size. The two main companies that make gel filters are Rosco and Lee Filters. Each of these companies makes a pack of sample swatches that are just about the right size for a typical flash head. These used to be available free of charge, but they generally charge a few dollars for them now. You can find these at lighting supply houses that specialize in motion picture lighting equipment, or you can order them straight from the manufacturer.

For the most part I only recommend using gels for lighting the background to add ambience. If you do use a gelled flash for front lighting, you will run into the problem of having highly saturated colors, which is what you are trying to combat in the first place. You can, however, use a very pale, almost transparent gel to add a slight color change.

Gear

There are no hard and fast settings for this technique of off-camera flash because every venue is different, and even the same venue can be different depending on where the band members have set up. One thing is certain, however: you will need at least one remote flash and a device to trigger the remote flash wirelessly. There are a number of different options, which range from cheap to very expensive. There are caveats to all of the options, and I'll quickly touch upon the most popular options.

The most obvious solution is to look to the manufacturer's accessories. Almost all camera systems have a proprietary flash system that allows wireless operation. The Nikon Wireless Speedlight Commander SU-800 or the Canon Speedlite Transmitter ST-E2 is what I recommend overall, because they use invisible, infrared pulse modulation technology to trigger the remotes. Some accessory flashes and built-in flashes allow you to control remote flashes

wirelessly, but they require a visible flash burst, which brings you back to flashing in the performer's face. These types of transmitters are sometimes referred to as *line of sight* transmitters, because the commander must be visible to the remote flash's sensor to receive the commands. When using these there's a probability of misfiring due to limited sight distance.

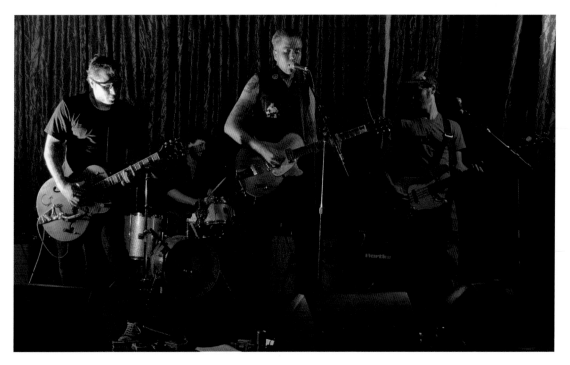

3.10 *For this shot of local Austin rockers Monarch Box, I set up a flash on either side of the stage using a clamp to attach them to a fixture on the wall. Using the Nikon Wireless Speedlight Commander SU-800 I triggered the lights using TTL metering. Taken with a Nikon D300s with a Sigma 17-70mm f/2.8-4 at 32mm (48mm equiv.). Shot at ISO 1250 for 1/60 at f/5.6, matrix metering.*

The biggest benefit of using the manufacturer's accessories is having the ability to control of the remote flash setting right on the camera.

The most reliable solution is to use radio triggers. These use radio signals to trigger the remotes, which doesn't require a line of sight between the commander and the remote flash. The downside to this is that each remote flash must have its own receiver. Radio triggers come in a variety of price points; you can find a cheap

set of radio triggers on eBay for less than $50, or you can go the more expensive route and spring for a couple of PocketWizard Wireless FlexTT5 Control TL transceivers, which will cost you about $500.

Settings

Your settings options will vary depending on the type of equipment you're using and the amount of available light at the scene. Your two main options are using flash in the automatic mode (i-TTL, ETTL, etc.) or manually. There are advantages to doing things either way, and neither way is better than the other.

For exposure settings, using manual exposure is best. Using a moderate shutter speed of 1/60 to 1/30 allows you to capture some of the ambient light. On occasion I will drag the shutter and use a slower shutter speed for light trails, allowing the short duration of the flash to freeze the subject. Using a moderately high ISO setting is also advisable, anywhere from 400 to 800 is good. This allows the flash to fire at a lower power, which in turns shortens the recycle time, allowing you to shoot at shorter intervals.

TTL

TTL is short for Through The Lens. This moniker is derived from the way the camera determines the exposure, which is by taking a reading *through the lens*. Each camera manufacturer has a specific proprietary system with its own designation. Nikon's is i-TTL (intelligent through-the-tens); Canon has designated theirs E-TTL (evaluative through-the-lens); and so on. The upside to using a TTL system is that you can let the camera do all of the light readings for you and you can focus on composition.

This option is available when using the manufacturer's wireless transmitters. There are two companies that offer a radio trigger that operates with the camera's TTL system, PocketWizard's FlexTT5 series and RadioPoppers. These radio triggers are pretty expensive; for a transmitter and two receivers, be ready to spend at least $750.

Manual

Setting the output of your flashes manually yields the most predictable and consistent exposures as long as the subject stays more or less the same distance from the flash. Using a proprietary system allows you to control the output directly from the camera, but using most common radio triggers requires you to set the output directly from the flash unit itself.

There's no right setting when setting up your flashes manually; the venue lighting and the flash-to-subject distance play a big factor. There's generally a bit of trial and error until you find the right exposure. Starting off with a lower output allows you to conserve battery life and shorten recycle time. Sticking between 1/32 to 1/4 power is advisable.

CAUTION

Firing your flash multiple times consecutively at a high power setting can cause your flash to overheat.

GN / D = A

An easy way to figure out what output level to set your flash is using the GN / D = A formula, or Guide Number divided by Aperture equals Distance. The Guide Number is a number that denotes how much illumination the flash can provide at any given setting. Your flash's user manual will have a table that breaks down the Guide Number at different settings. Using the GN you can divide by the Aperture setting and determine the distance the flash needs to be from the subject. For example, the Nikon SB-900 has a GN of 25.2 at 1/16 power at the 17mm setting ISO 200. I know I am using an aperture of f/2.8, so 25.2 ÷ 2.8 = 9. The flash should be about 9 feet from the subject.

Using the commutative properties of math you can switch the equation around to figure out your output setting. D × A = GN, to wit, the flash is 12 feet from the subject at an aperture setting of f/2.8 and you need to have a GN of 33.6. Checking the user manual for my flash I see that I need to set the flash at 1/4 at the 17mm setting using ISO 100.

To adjust the GN for higher ISO settings simply multiply the GN at ISO 100 by 1.4 each time the ISO is doubled.

SLOW SYNC / REAR CURTAIN SYNC FLASH

Slow Sync is a technique that is achieved by doing long exposures in order to essentially capture two exposures at once, the flash exposure and the ambient light exposure. This gives the images an interesting look where the ambient light exposure is blurred, but the flash exposure freezes the subject. It's a great technique for portraying motion in your images. The effect on a moving subject ends up as a nice sharp image of the subject followed by light trails.

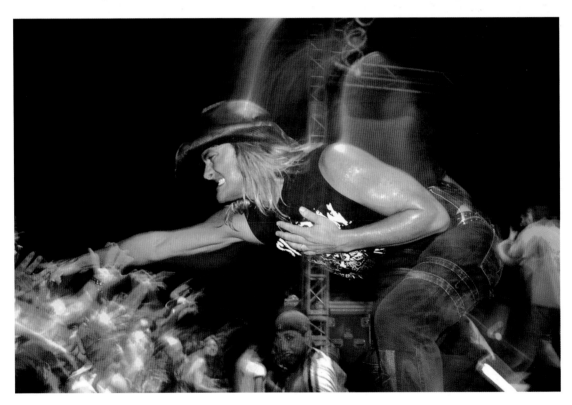

3.11 *Using Rear Curtain Sync can add a cool effect to images that you take with flash. Taken with a Nikon D70 using a Nikon 18-70mm f/3.5-4.5 at 18mm; ISO 200 for 0.6 seconds at f/3.5, matrix metering, Rear Curtain Slow Sync.*

When a flash fires in the normal setting it fires at the beginning of the shutter cycle when the first curtain of the shutter is fully open. This is great for most flash applications where the flash is the sole light source and even when doing moderately slow shutter drags of 1/30 to 1/15 of a second. But as exposures get longer when the flash fires at a subject, the initial pop freezes the subject, but as it moves forward an ambient light trail appears in front of the subject. This makes the subject appear to be moving backwards from the viewer's point of view.
To rectify this situation you can set the camera to Rear Curtain Sync, also known as Second Curtain Sync in Canon vernacular. This causes the camera to fire the flash at the end of the shutter cycle as the rear curtain of the shutter is closing. This freezes the subject at the end of the movement, and the ambient light trail follows behind the subject, which makes for a more natural look.

Slow sync can also be used in conjunction with zooming your lens in or out, which gives an effect suggesting the subject is moving towards you. You can also experiment with moving the camera, turning it sideways and twisting it around to achieve different effects. While these techniques are fun to use, they can get rather gimmicky if used too much, so I recommend only using them sparingly.

OUTDOOR CONCERTS AND FESTIVALS

Covering a festival is unlike any other event you'll ever shoot. Photographing a festival such as Bonnaroo, Lollapalooza, Austin City Limits, or any of the hundreds of other festivals that have cropped up over the past ten years is an exercise in maintaining your stamina.

When shooting a festival you will need to cover all of the bases of concert photography, from small stages that are poorly lit (similar to bar lighting) all the way up to huge stadium-sized stages. Most festivals have a variety of stages depending on what career level a band is at. The newer bands usually play the smaller stages, often called *side stages*, while the main stages are generally reserved for headliners. The lighting covers all the bases as well, because you will be required to shoot throughout the day at different stages in constantly changing lighting situations. Shooting a festival really keeps you on your toes.

The other thing you really need to be on top of when shooting a festival are your post-processing skills. You need to get the images edited and available right away to maximize sale potential. Even if you don't need to get the images up right away, editing on the fly allows you to avoid spending hours upon hours editing thousands of images down the line.

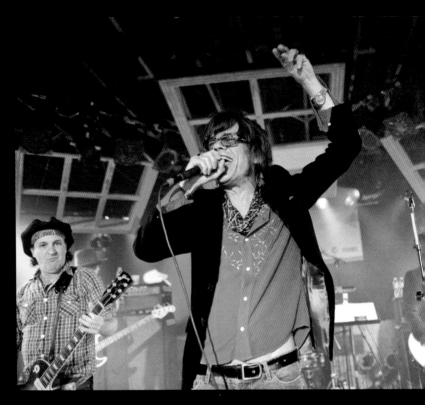

4.1 *Every festival has different lighting setups and types of stages. The SXSW Music Conference that features thousands of bands on hundreds of different stages. Here the New York Dolls play S D700 with a Nikon 28-70mm f/2.8D at 28mm; ISO 3200 for 1/160 at f/2.8, matrix metering.*

PLANNING

The key to successfully surviving a festival is planning. Yes, I said surviving, because without the proper planning you will run yourself ragged and in the end you won't have any fun. And let's face it, we all started in this field of photography because we love music and photography and ultimately want to have fun.

Planning for a festival comes in stages and starts weeks before the festival actually begins. Most festivals these days have dropped the "touring" business model and have opted for a once-a-year multiday event at a certain location, however there are still a few touring festivals out there such as the Warped Tour and the Mayhem Festival.

First and foremost in the planning process is getting credentialed and securing a photo pass. In theory, it's a simple process, but actually getting credentialed is the real trouble. To start off, you need to find an outlet to shoot for. Festival promoters

4.2 *Once you have secured your credentials you're ready to shoot!.*

aren't interested in filling up the press areas and photo pits with photographers looking to add to their portfolio, so you *will* need an assignment. Your local newspaper, a magazine, or a webzine are all good places to start. Particularly successful blogs are often accepted as well. For the most part, approaching an outlet that is music-based is going to be your best bet when looking for an entity to shoot for.

Go to the festival website and find the press area; there will be a link to a press application. Have a letter of assignment on hand to attach to the form. The PR agencies *will* check for the validity of your assignment, so don't even think about trying to make something up. If they find out you've submitted a fraudulent form, your name will likely be red-flagged and you'll be blacklisted from this and any other festival the PR firm handles. This is no joke.

Scheduling

Once you've been credentialed the next thing on the planning list is scheduling. You need to decide which bands are important for you to shoot and cross-reference them with the time they're playing and at which stage they'll be performing. Scheduling is like choreography. If you don't get it just right you'll trip and fall.

The first step is taking a look at the lineup to see who's performing. Selecting which bands to shoot is very subjective. There's a few ways to look at it depending on the scope of your assignment. If you've got carte blanche to shoot whatever you want, you can go through and pick your favorite bands. Since I shoot for an agency, I depend on sales to make money, so I select bands or performers that I know have the potential to sell images. Headliners, hot up-and-comers, and established acts that may be doing a reunion are all good candidates.

4.3 *Jimmy Buffet made an unannounced appearance at Bonnaroo 2009. Surprise appearances are a great opportunity to sell photos. Taken with a Nikon D300s with a Nikon 80-200mm f/2.8D at 200mm; ISO 200 for 1/1250 at f/2.8, spot metering.*

If you're on assignment you may be need to cover specific bands, so that makes it a little easier to set your schedule, although there may be conflicts in scheduling times. Some photographers on assignment shoot only what they have been asked to shoot, some shoot other things as well if they have ample time.

Once you've decided which performers you want to cover the next thing to do is look at the scheduling times. Most festivals have online schedules that make it pretty easy to make a layout of your schedule. Obviously you can't be two places at once, and there will be a lot of times where there are overlaps where two bands you want to shoot are playing at the same time. You have to make a decision about which performer is more important to you.

One of the main problems that you run into is setting up a realistic schedule. As with most concerts you can only shoot the first three songs on most of the stages, and if you have two bands that start 5 or 10 minutes apart, it's unlikely you will be able to shoot them both. You must also remember to factor in travel time between stages, and don't forget you will have to deal with the crowd, which can add quite a few minutes to your travel.

The first time you schedule for a festival it's easy to overbook yourself. Don't get frustrated if you can't get to everything you want to get. The best thing to do is to schedule the things you *want* to shoot, and set priorities for what you *have* to shoot. As you shoot more festivals and shoot the same festivals over again, scheduling gets easier, as you have a better idea of how much time it takes to travel back and forth to the different stages.

Once you've finished setting your schedule be sure that you have a copy of it when you're on site. You don't want to have to recheck the schedule and decide from memory. Most festivals offer an online scheduling application that shows you the lineup and set times and lets you select the bands that you want to shoot, and then builds a personalized schedule for you. Most festivals now have smartphone apps that allow you to do your scheduling right on your phone, and some of the websites allow you to export your personalized schedule to smartphone apps such as Apple iCal.

I have come to rely on my iPhone as an integral piece of my gear when shooting a festival. Having quick access to your personal schedule right at your fingertips is key to keeping your schedule running smoothly. Of course, I always print out a hard copy and keep it in my bag just in case.

Packing

Shooting a festival is when you will need to pack the most gear. It's essential to be prepared for any type of shooting situation. Not only do you need to be prepared for every type of shooting situation, you also need to be prepared for

Tip: Keeping your eye on music magazines such as SPIN and Rolling Stone a few months ahead of time will help you keep abreast of the up-and-coming acts. Sometimes these acts are booked into the festival before they get really famous, so you may be able to catch a future headliner on a smaller more intimate stage.

4.4 *The Bonnaroo Apple iPhone app is a real timesaver. Not only does it allow you to create your own schedule but it also has a map so you can find your way from stage to stage easily.*

4.5 *The BlackRapid DR-1 strap, as seen here on live music photographer Amber McConnell, is the best strap that I've found for comfortably carrying two heavy pro cameras all day.*

any type of weather situation. Remember, you'll be outdoors most of the time, and you never know when the weather might change at the drop of a hat. You need to be able to protect yourself and your gear from any type of inclement weather.

Another important consideration to factor in while packing for a festival is sustenance. You will hardly have time to eat or drink for most of the day, so packing some snacks is a good idea, and bringing along a water bottle is imperative. Some festivals will have water available, but a lot of them don't. Staying hydrated on a hot summer day is very important, because you'll be doing a lot of running around and sweating.

Here's a list of what I believe are the most essential pieces of gear to have with you when shooting an outdoor multiday festival. You may or may not need or even use everything in your bag, but it's better to be prepared than to be caught off guard.

1. **Camera bodies** – Having two camera bodies is ideal, one with a standard zoom lens and one with a telephoto lens. This allows you to quickly switch cameras rather than swapping lenses in the thick of it, and you'll likely be covered in all shooting scenarios. Having two identical bodies or two bodies with the same layout is the best option, so you're not fumbling around looking for buttons when switching between the two. Having a weather-sealed body is highly recommended.

2. **Lenses** – Carry a minimum of three lenses: an ultra-wide to wide-angle zoom, a standard zoom, and a telephoto zoom. My standard kit consists of a Nikon 14-24mm f/2.8, a Nikon 28-70mm f/2.8, and an 80-200mm f/2.8. With this complement of lenses I'm covered no matter what I run into. In my main camera bag, but not necessarily with me at all times, I also carry a 50mm f/1.4 fast prime for portraits, a fisheye lens for scenic shots and special effects, and a 2X tele-converter in cases where you might have to shoot from the soundboard.

3. **Laptop computer** – You will invariably need to download and edit your images at various points throughout the festival. I recommend having a fast computer with plenty of RAM so that you don't get bogged down while editing large quantities of files. For the first festival I shot digitally I brought my older backup computer and it wasn't quite up to par, so I spent a lot more time waiting for my files to process than I wanted to. Speed is the key when you're on a deadline. Of course, if you're not on a deadline you may not need a very fast computer. Don't forget to pack your power supply.

4. **Accessories** – There are lots of smaller accessories you'll need to pack. All of them are pretty important. It's a good idea to make a checklist of these things so you don't accidentally leave anything behind.

Batteries – It's a good idea to have at least two batteries per camera.

Charger – Of course you'll need to charge those batteries.

Memory – Bring enough memory cards to last the whole day if you need to. You'll likely be shooting hundreds if not thousands of images. I bring *at least* 20GB of memory. Don't forget to bring a card reader as well.

Strap – A comfortable strap is a necessity. The BlackRapid strap seems to be the preferred strap amongst concert photographers today. I use the two-camera version; it's comfortable, doesn't tangle up your cameras, and is extremely quick to use.

Small shoulder bag – A small pouch or bag in which to hold your extra lenses and various other accessories and snacks. I use a military tactical shoulder bag that has various compartments in which to store things. This bag is also equipped with the molle system, which allows you to attach other pouches to it externally if needed. As an added bonus, this bag is also waterproof.

Lens cloth – To keep your lens clean and free of smears and smudges.

Flashlight – Bring a small flashlight to help you see when it gets dark out. It's great for finding things that get dropped in front of a dark stage, and it can help you navigate through a crowd at night.

Rainsleeve – This is a must for every festival photographer's bag. It will allow you to shoot in the rain and can also protect your camera if it's dry and extremely dusty. Op/Tech sells them in packs of two for just around $6.

Rain poncho – Being caught in a quick downpour isn't much fun, but if you have to shoot all day in the pouring rain, you'll be really glad you brought a rain poncho along.

Hat – A hat is an invaluable piece of equipment when you're out in the sun all day.

Earplugs – This should be standard equipment for *every* concert photographer. Having suffered minor hearing loss and tinnitus, I am a staunch proponent of hearing protection.

Snacks – It's important to have a few snacks handy to keep you going through the day; granola bars or some sort of energy bar are great. I also bring some candy along to avoid hypoglycemia. Candy also is a good way to make friends with your fellow photographers. In the summer, carrying around a bottle of water or sports drink is also advisable.

4.6 *Flogging Molly performs here in the pouring rain at Austin City Limits Music Festival 2009. Taken with a Nikon D300s with a Nikon 80-200mm f/2.8D at 145mm (217mm equiv.); ISO 720 for 1/250 at f/2.8, spot metering.*

SHOOTING

As I mentioned previously, when shooting festivals, especially the larger ones, you will run into almost every type of shooting scenario: from daylight shooting, to shooting in the dark with almost no light, to shooting full-on stage production lighting. Your camera settings are likely to be different for every different stage you shoot and will also change as the day progresses and the lighting changes. This isn't a "set it and forget it" shooting scenario.

4.7 *Shooting through smoke adds a cool effect to your shots, such as this one of Jay-Z at Bonnaroo 2010. Taken with a Nikon D700 with a Nikon 80-200mm f/2.8D at 125mm; ISO 640 for 1/250 at f/2.8, spot metering.*

Daylight shooting

Shooting in the daylight is usually a very easy option, although there are some pitfalls you should watch for. For the most part you will find that the performers are under cover, the lighting is soft and even, and the stage lighting adds a small bit of color highlights.

4.8 *Nice even lighting makes shooting in the daytime a breeze. Here we have John Gourley of the band Portugal. The Man performing at a small stage at Bonnaroo 2009. Taken with a Nikon D700 with a Nikon 28-70mm f/2.8D at 70mm; ISO 200 for 1/125 at f/2.8, matrix metering.*

Daylight shooting settings are relatively straightforward when the band or performers aren't in direct sunlight. The best option is to use matrix or evaluative metering. Basing your exposure on spot metering can yield very over- or under-exposed images, depending on where you place the spot. Center-weighted metering can work if you are placing your subject directly in the middle of the frame, but if you're composing using the rule of thirds, center-weighted can throw off your exposure.

Although shooting in the daylight is great because you get consistent exposure and soft lighting, your images can often come out looking flat and lacking in contrast. You can add contrast by adjusting your in-camera settings, such as Nikon's Picture Controls or Canon's Picture Styles. Keep in mind that if you're shooting RAW you may need to use your camera's proprietary software to apply these changes when opening your RAW files.

Even in daylight when there is plenty of light most photographers still prefer to shoot wide open to get the shallow depth of field that helps to isolate the performers from the background, which is usually more evident in the daylight than it is at night.

One of the major pitfalls when shooting out of doors in the daytime is that once in a while you will have to shoot with direct sunlight shining directly on the performers, which can lead to hotspots (overexposed patches) on your images. In this situation applying some negative exposure compensation can help to keep detail in the bright spots. You may want to set your camera's image review option to display highlight warnings; most cameras are equipped with this feature.

Another thing to look for is backlighting. The sun can sometimes shine into the lens from behind the stage, which can make it difficult to get an accurate meter reading. Switching to spot metering and metering on the performer can help you avoid underexposing the subject. Backlighting isn't necessarily a bad thing; placing your subject between you and the light source can add a nice rim-light effect similar to the lighting technique that portrait and fashion photographers use to help separate the subject from the background.

As with any type of photography, the "golden hour" is one of the best times to get great lighting when shooting during the day. The golden hour is the time right before sunset when the sun is low in the sky, which bathes the performers in a nice golden light. This isn't the most common shooting scenario, but you will run into it from time to time as you progress into shooting festivals and outdoor events.

4.9 *Shooting wide open allowed me to blur out some of the distracting features in the background of this shot of Kris Kristofferson at Willie Nelson's 4th of July Picnic 2010. Taken with a Nikon D700 with a Nikon 28-70mm f/2.8D at 65mm; ISO 450 for 1/100 at f/2.8, matrix metering –0.3EV.*

4.10 *Backlighting provided a rim-light that separated Britt Daniel of the band Spoon from the dark background that could have caused him to blend in. Shot during the Austin City Limits Music Festival 2010. Taken with a Nikon D700 with a Nikon 80-200mm f/2.8D at 200mm; ISO 200 for 1/1600 at f/2.8, spot metering –0.3EV.*

4.11 *French indie rockers Phoenix headlined the last day of Bonnaroo 2010 just as the sun was setting, giving the stage and performers a nice golden glow. Taken with a Nikon D700 with a Nikon 80-200mm f/2.8D at 200mm; ISO 1100 (Auto-ISO) for 1/320 at f/2.8, matrix metering.*

Night Shooting

Shooting an outdoor concert at night isn't that far off from any other concert shooting experience. Your settings will largely depend on the lighting setup, the same as any other venue. Smaller festivals tend to have less of a lighting budget than the larger festivals, so you may have to push the limits of your camera when shooting smaller festivals. As usual it's best to have a fast lens.

When shooting the smaller or side stages, you are generally going to encounter lighting similar to what you will find in a bar: a few PAR cans or LED lights. These lights are generally going to be a constant light source, so your settings won't necessarily need to be changed much once you get the exposure in the ballpark. You can use spot or center-weighted metering, depending on how focused the lights are on the performers. Some lights tend to be less diffused

than others, depending on the lamps used in them, and if they are using filters or not. Generally, center-weighted metering is a safe way to go.

As with bar and small club lighting, the highly saturated lighting is going to be one of your biggest obstacles. Refer to Chapter 3 for advice on how to deal with these types of lights.

As you move to shooting the main stages you are going to be dealing with more complex lighting setups. There are lights of every color, and they flash and blink and sweep across the stage. These types of professional stage-lighting setups are very tricky for camera meters, therefore the best way to avoid all of the flashing lights tricking your meter is to use your camera's spot meter. Most current DSLR cameras have the spot metering linked to the active focus point.

The general rule when focusing is to focus on the performer's eyes, usually the one closest to you. This tends to be a good area to meter an exposure reading from as well. This allows you to expose for the most important part of the image, which is the performer.

Sometimes, however, you may find that there is a brighter area on the performer, and you may need to adjust your exposure to help reign in the highlights. This often happens when a performer is wearing a bright white shirt. In this case you can meter on the shirt and use the camera's Auto-Exposure Lock feature, then recompose the image, placing the focus point on the eye but retaining the exposure settings for the bright area of the performer.

4.12 *Spot metering allowed the camera's metering system to ignore the backlight shining into the lens so that I could get the correct exposure for this shot of punk legend and singer for the Descendents, Milo Aukerman. Taken with a Nikon D700 with a Nikon 28-70mm f/2.8D at 52mm; ISO 3200 for 1/125 at f/2.8, spot metering.*

4.13 *Metering the shirt and recomposing the image allowed me to retain the highlight detail in the white areas that would have been overexposed had I metered from the face. David Byrne at Bonnaroo 2009. Taken with a Nikon D700 with a Nikon 80-200mm f/2.8D at 105mm; ISO 3200 for 1/80 at f/2.8, spot metering.*

One of the most common problems that you will encounter when shooting festivals, especially the smaller ones, is that the lighting setups don't have a lot of front spotlights, which really help to light the performer. This can often lead to underexposure and high ISO settings, resulting in somewhat noisier images. Overexposing half to one stop from you meter reading helps to keep detail in the shadow areas.

4.14 *The lack of adequate front lighting necessitated me overexposing the image by one stop. The Reverend Horton Heat performs at the Revival Festival 2011 in Austin, TX. Taken with a Nikon D700 with a Nikon 28-70mm f/2.8D at 42mm; ISO 3200 for 1/250 at f/7.1, spot metering.*

As I mentioned earlier in the chapter, having a variety of lenses is a necessity when shooting a festival. The size of the stages can vary greatly, and not having the right lenses with you will definitely limit your ability to compose properly.

There are three types of lenses you should have in your bag at all times when photographing; an ultra-wide zoom, standard zoom, and telephoto zoom. It's entirely possible to shoot with just the standard zoom and the telephoto zoom, but you must have these two options at the very least to get the job done.

The ultra-wide isn't one of the lenses that you'll find yourself using all the time when shooting a festival, but it's definitely a plus to have one available. When shooting small- to medium-sized stages the photo pits are generally pretty tight. Using the ultra-wide lens allows you to capture shots of the full band when packed in a tight area where you can't back up. On the smaller stages, ultra-wides also allow you to get more creative with your compositions by using the intense distortion that these lenses create.

4.15 *I used an ultra-wide lens to add an interesting twist to this photo of the Decemberists at Bonnaroo 2009. Taken with a Nikon D700 with a Nikon 14-24mm f/2.8g at 14mm; ISO 800 for 1/320 at f/2.8, spot metering.*

Ultra-wides are also useful when photographing performers on the main stages. The ultra-wide angle of view allows you to create images that fit the whole scene in, which is great for adding perspective to a shot. These lenses are also great for capturing a scene when a good light show is happening: instead of just focusing on the performers you can include the light show, which allows your viewers to feel like they were there.

4.16 *Using an ultra-wide lens allowed me to capture the intense stage lights from Phish's performance at Bonnaroo 2009. Taken with a Nikon D700 with a Nikon 14-24mm f/2.8g at 14mm; ISO 360 for 1/125 at f/2.8, spot metering.*

The standard zoom is going to be your go-to lens for the smaller to medium stages. The focal length range of these lenses is ideal for capturing a number of different shots. From full to partial band shots or full-length body shots, to close-ups at the longer end. The wide-angle setting isn't going to give you quite the same effect as the ultra-wide but will get you in the ballpark. On the main stages you can use the standard zoom to get full band and stage shots.

4.17 *A standard zoom lens is perfect for capturing shots on the small to medium stages. Here Ben Nichols of the alt-country band Lucero performs at Fun Fun Fun Fest 2009 in Austin, TX. Taken with a Nikon D700 with a Nikon 48-70mm f/2.8D at 45mm; ISO 1800 for 1/200 at f/2.8, spot metering.*

The telephoto lens is an absolute necessity when shooting the larger main stages. Most of the time the stages are about 15 feet high. Using a telephoto and backing up in the pit is the only way to get a good perspective of the performer; trying to stand up close to the stage and shoot upwards with your standard zoom lens will result in a lot of "up the nose" shots. On the smaller stages the telephoto is great for getting those close-up shots.

4.18 *Using a telephoto was a necessity when photographing the Avett Brothers on the main stage at the Austin City Limits Music Festival. Taken with a Nikon D300s with a Nikon 80-200mm f/2.8D at 105mm (157mm equiv.); ISO 200 for 1/1250 at f/2.8, matrix metering.*

One thing to remember when shooting a festival is to capture the scenery. Festivals are always a good time for catching a party atmosphere. There are usually lots of interesting people doing any number of fun things. Look for people enjoying the music, interacting with their friends or even the performers; in short, look for general revelry. Don't be afraid to approach people and ask them to pose for you.

4.19 *I caught this family as they were heading home on the final day of the Austin City Limits Music Festival 2009. Taken with a Nikon D700 with a Zenitar 16mm f/2.8; ISO 500 for 1/60 at f/5.6, matrix metering.*

4.20 *After two days of torrential downpours, the entire Austin City Limits festival grounds were covered in mud. This kid decided it would be fun to roll around in it. Taken with a Nikon D700 with a Nikon 80-200mm f/2.8D at 200mm; ISO 200 for 1/400 at f/2.8, spot metering.*

Another thing to photograph is the scenery and the festival grounds. Festivals usually have more than just music going on. There are often art installations and other fun things that will help you to portray the festival theme. Inclement weather can play a role in the overall scenery and atmosphere of the event as well, so don't forget to include some scenic shots of the festival, especially if the weather turns nasty. A few years ago it rained heavily for two days during the Austin City Limits Music Festival, turning the whole place into a mud pit, and some of my favorite scenic shots are from this part of the event.

4.21 *The Bonnaroo ferris wheel is one of their iconic structures. Using a fisheye lens allowed me to get a cool perspective. Taken with a Nikon D700 with a Nikon 16mm f/2.8; ISO 200 for 1/2000 at f/5.6, spot metering.*

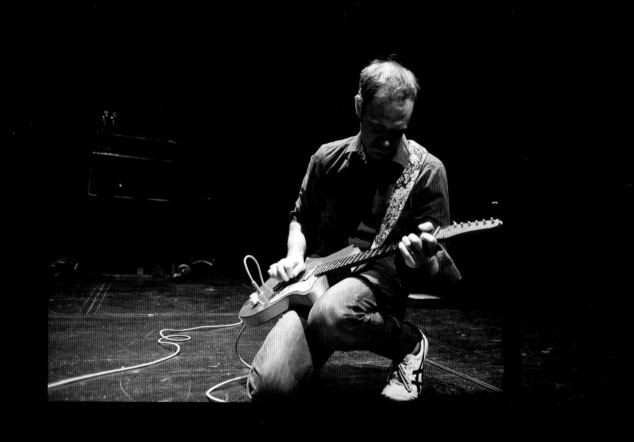

THEATERS

Theaters are the *odd ducks* of concert venues, not as small as a club or bar but not quite as big as an arena or amphitheater. Theaters are designed to take a medium to large event and give it more of an intimate setting.

Theaters typically have seating, and most theaters usually don't provide a photo pit, but there is generally a good amount of space between the first row of seats and the stage. The patrons are likely sitting down, and the performances are usually relatively low-key, such as blues singers, jazz players, or solo musicians. For this reason the theater venues often have different restrictions than your standard rock concert. Most of the venues have restrictions on where you can shoot from and how long you can shoot for. Unlike the customary "in the photo pit, first three songs, no flash" stipulation of concert venues, theaters generally require you to shoot from the aisles alongside the seating rows as opposed to at the front of the stage, and they usually place a time limit of about 2 to 5 minutes for shooting.

If you are permitted to shoot from the front, it's important that you keep the fans in mind. Theater performance tickets are usually sold at a higher premium price than your standard concerts, and I have found that theatergoers are often a bit more vocal about photographers getting in the way than your average rock concertgoers. The key is to keep down as low as you can while in front. Popping your head up and grabbing a few shots in fine, but standing in front of the patrons is not in good form.

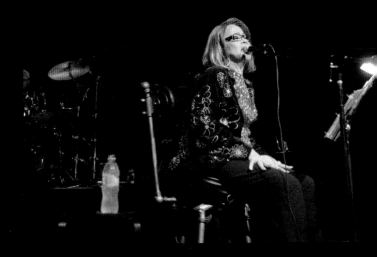

5.1 *While shooting this rather low-key gig of blueswoman Etta James, I was assaulted by a man by the photographers near the edge of the stage. Taken with a Nikon D700 with a Nikon 28-70mm 1/320 at f/2.8, spot metering.*

Explaining to anyone who questions you about being in their way that you're just there to do your job and you'll only be a few minutes is usually enough to placate most theatergoers. Sometimes you will come across the one bad apple that crosses the line and may physically accost you. In this situation remain calm and find the nearest security guard. It's best not to continue the altercation, as it could lead to you being banned from the venue.

Even in cases where there is a barricade and a photo pit there will sometimes be people who will be verbally abusive. It's best to just ignore these people, shoot for the allotted time, and move on.

LIGHTING

Lighting in theaters usually lies somewhere between club lighting and arena lighting. That is, sometimes it's bad and sometimes it's good. The best way to describe most theater lighting is adequate. Theater lights aren't designed for the elaborate lighting shows that you often see at large rock concerts but for performances that require a more consistent lighting quality. This means that your exposure setting will also stay very consistent, but the lighting may lack the variety that you will get in an arena setting.

The light sources in most theaters these days are usually the standard tungsten spotlights with gels added when color is needed. Setting your white balance to tungsten will get your image looking very close to what the lighting designer intended. Even if you're shooting in RAW setting, the correct white balance can help to cut down on your post-production time.

5.2 *Ani DiFranco at the Paramount Theatre in Austin, TX. This is a beautiful venue, but the straight tungsten lighting can often lack the vibrancy that you get in venues designed specifically for concerts. Taken with a Nikon D700 with a Nikon 80-200mm f/2.8D at 155mm; ISO 720 (Auto-ISO) for 1/200 at f/2.8, spot metering.*

You will run across concerts in theaters where the performers bring their own stage lighting that is more geared towards the concert than the traditional theater's lights, and on occasion there are a few theaters that actually cater

5.3 *Some theaters will have more elaborate lighting setups for special events. Here Ozomatli performs at the Joe and Teresa Long Center for Performing Arts for the 2010 Los Premios Texas Awards. Taken with a Nikon D700 with a Nikon 28-70mm f/2.8D at 28mm; ISO 280 (Auto-ISO) for 1/125 at f/2.8, spot metering.*

towards concerts, such as the Moody Theater in Austin, TX. These situations sometimes play out more like an arena-type concerts, so check out Chapter 6 for more information on these types of shows.

check out Chapter 6 for more information on these types of shows.

GEAR

There's not a lot of gear that you need to bring when shooting a theater gig. A standard zoom and a telephoto zoom are the best lenses to carry with you, and if you don't mind swapping out lenses from time to time, you can stick with one camera body. I generally like to travel light to smaller gigs, and I don't mind swapping lenses, so I bring one camera body and the two aforementioned lenses.

5.4 *Having a long lens can be a great advantage if you're afforded the opportunity to grab some shots from the balcony. This is a great way to get photos of the whole band all at once, as I did here with the band Cracker at the Moody Theater in Austin, TX. Taken with a Nikon D700 with a Nikon 80-200mm f/2.8D at 165mm; ISO 2000 for 1/200 at f/2.8, spot metering.*

If you're shooting from the side aisles you'll probably find that a telephoto lens will be your best option, so if you know for sure that you will be shooting from the sides you may not need to bring your standard zoom at all. One option you may consider is bringing along a monopod. I never recommend using a monopod in a standard photo pit, because they are intrusive to the other photographers, especially when you're in a confined space where there's a lot of movement. But in the case of shooting in a theater, if you are planted in one spot I don't see a problem with using one.

RECOMMENDED SETTINGS

Getting a good metering and setting your exposure manually is the best option when shooting in theaters. As I mentioned before, the lighting is usually fairly consistent, so you won't have to worry about switching your settings very much. If the lighting is spotty, you can try using Shutter Priority along with Auto-ISO to keep your exposures relatively even if the performer moves into a position in between

5.5 *Adding a sepia tone in post-processing allowed me to give this image of Bo Diddley at the Paramount Theater a vintage feel. Taken with a Nikon D200 with a Nikon 80-200mm f/2.8D at 200mm; ISO 1250 for 1/320 at f/2.8, spot metering.*

the spotlights where the light is a bit lower. This will allow you to set your shutter speed fast enough to freeze motion. The lights are generally low enough that you will be at a constant wide open aperture, and the camera will control keeping the exposure consistent by adjusting the ISO sensitivity.

For exposure, metering using spot metering is the best way to go. The spotlights at theaters have a tendency to have a rather abrupt light falloff, so taking your exposure reading from the focus point spot is preferable. If you are composing with the main subject in the center most often, you can also easily get a pretty consistent exposure reading using center-weighted metering. Try both and see which one works better for you.

5.6 *A strongly lit backdrop can add some interest to your images. If there is stage scenery at the performance, try to keep an eye out for it and work it into the composition. Taken with a Nikon D700 with a Nikon 28-70mm f/2.8D at 70mm; ISO 640 (Auto-ISO) for 1/320 at f/2.8, spot metering.*

STADIUMS, AMPHITHEATERS, AND ARENAS

Photographing performances in stadiums, amphitheaters and arenas is the culmination of years of hard work in the concert photography business. We start out in bars and clubs and work our way up in hopes of one day being afforded the opportunity to photograph the world's top performers. This is where photographers get the chance to make some of their best shots.

6.1 *All your hard work in photography can lead to you landing gigs like photographing Green Day at the AT&T Center in San Antonio, TX. Taken with a Nikon D700 with a Nikon 28-70mm f/2.8D at 28mm; ISO 900 (Auto-ISO) for 1/200 at f/2.8, spot metering.*

The lighting setups at these types of events are top-notch, but this is also where you find some of the most difficult shooting situations due to the fact that lighting changes continuously from second to second. This requires you to be vigilant about keeping an eye on your exposure settings and constantly adjusting them as needed to get the best exposure.

6.2 *Large venues such as the Seaholm Power Plant in Austin, TX usually have complex lighting. Here you see at least three different light sources in this picture of psychedelic rock legend Roky Erikson. Taken with a Nikon D700 with a Nikon 80-200mm f/2.8D at 112mm; ISO 3200 for 1/100 at f/2.8, spot metering.*

Photography at these types of venues is usually done from the photo pit, which is an area in front of the stage that is blocked off by barricades. Photo pits vary in size, but they generally aren't more than three or four feet wide. This leaves you ample room to move about, but it can get crowded depending on the number of photographers that are approved to shoot the event. Having a limited depth to work in doesn't afford you the opportunity to move forward and backward, which is why I recommend using a zoom lens rather than a prime lens to make composition much easier. Remember to be courteous to your fellow photographers when you're packed into a tight photo pit.

The larger stages at these events allow you to get a little more creative with your compositions. The performers are usually at the top of their game and really put on a show for the crowd, which means the photographer gets more chances to create images that are more interesting than the standard shot of the artist standing there singing into the microphone, or the guitarist standing still strumming. Keep an eye out for the action, and try to anticipate when one of the performers is going to do something compelling. Catching a performer leaping or in an intense moment of singing, or a guitarist really getting into his playing, are going to give your photos more interest than static shots.

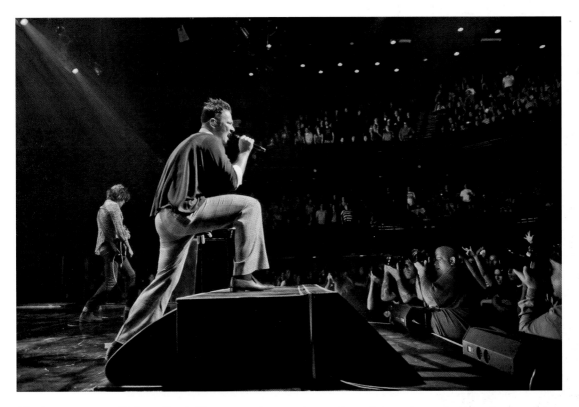

6.3 *As you can see at this Stone Temple Pilots concert there are almost a dozen photographers packed into a tiny area (I'm third in from the right). Being considerate of your fellow photographer is the only way to make things work smoothly. Taken with a Nikon D700 with a Nikon 28-70mm f/2.8D at 28mm; ISO 3200 for 1/250 at f/4, matrix metering. Photo © Dave Mead*

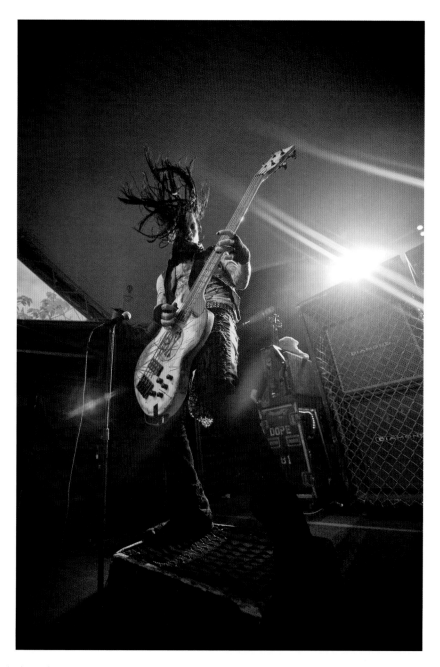

6.4 *Catching the bass player Derrick "Tripp" Tribbet from the rock band Dope as he was headbanging with his hair straight up shows some action in the scene. When photographing a particularly fast-moving band you sometimes need to use a faster shutter speed to freeze the motion. Taken with a Nikon D700 with a Nikon 14-24mm f/2.8D at 14mm; ISO 1000 for 1/320 at f/2.8, matrix metering.*

One thing that photo editors and PR people often look for is the band interacting with the audience. This shows that the band is still down to earth and appreciates their fans. Catching a band leaning into the audience or having the audience sing along with them is always a great shot.

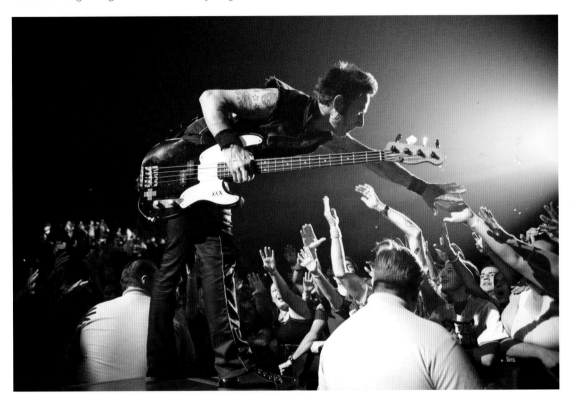

6.5 *Here we have Green Day bass player Mike Dirnt reaching out to the fans in the crowd. Taken with a Nikon D700 with a Nikon 28-70mm f/2.8D at 28mm; ISO 2800 (Auto-ISO) for 1/200 at f/2.8, spot metering.*

Sometimes for one reason or another the artist's management will not have a photo pit and will require photographers to shoot from another location. Generally they will require you to shoot from the soundboard, which is why this is usually called a *soundboard shoot*. The soundboard is most often near the middle or back of the venue at center stage. Having a long telephoto lens is a necessity when doing a soundboard shoot. At the very least you will need a lens with 200mm range. A fast 300mm f/2.8 prime would be the preferred option. You can also use a tele-converter as a last resort, but this will effectively reduce the aperture of the lens. Bringing a monopod to a soundboard shoot is also a very good idea to help reduce the effect of camera shake from using a long focal length.

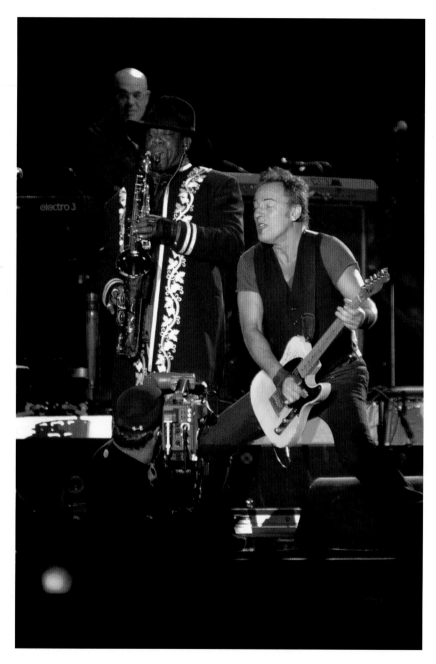

6.6 *To get this soundboard shot of Bruce Springsteen and his late saxophonist Clarence Clemons I used a camera with a 1.5X crop factor and a 2X tele-convertor, effectively turning my 200mm telephoto lens into a 600mm. Unfortunately, when using a 2X tele-convertor you also lose two stops of light, reducing an f/2.8 aperture to f/5.6. Taken with a Nikon D300 with a Nikon 80-200mm f/2.8D at 200mm; ISO 3200 for 1/400 at f/2.8, spot metering.*

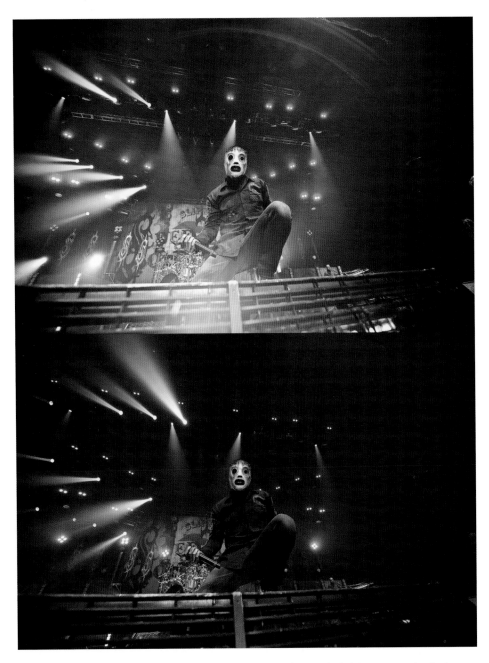

6.7 As you can see from this series of shots of Slipknot at the Freeman Coliseum, the lighting can completely change in a fraction of a second. Taken with a Nikon D700 with a Nikon 14-24mm f/2.8G at 14mm; ISO 900 (Auto-ISO) for 1/100 at f/2.8, spot metering.

The lighting at larger events that take place in stadiums, amphitheaters, and arenas is some of the most complex lighting you will have to deal with. The lights are controlled by numerous lighting techs, and a number of the light arrays are likely to be synced with the music. The lights of every color will be spinning, flashing, blinking, and moving all around. Every second you will be in a different lighting situation: it can go from pitch black to bright as daylight in the blink of an eye, so being quick with your reflexes and adjusting your settings on the fly is something that you will need to master.

In the most ideal of lighting situations you will have a spotlight that follows the performer. Spotlights are very bright and are usually white light, which gives you plenty of light for a good exposure; white light also ensures the most natural-looking colors in your images.

As with many other types of venues you will at times run into the problem of clipping individual RGB channels due to the high saturation of the color of the red, green, and blue lights. As I mentioned in Chapter 3, the best way to deal with this is by dialing back the exposure by a stop or two. It is important that you can recognize when this is happening so you can quickly adjust your exposure to retain as much detail in the image as possible. See Chapter 3 for more detailed information on clipping RGB channels.

There are a number of difficult lighting situations that will arise from time to time when photographing shows with very complex lighting rigs. One of them is dealing with strobe lights. The strobes that they use in concert lighting are almost exactly the same as a camera flash, but in this situation you aren't in control of when they fire, which makes it difficult to catch any usable images except by accident. If the strobes are firing in the background while the rest of the stage lighting is lit, then the strobes aren't much to worry about. The problem arises when the stage lights are all turned off with the exception of the flashing strobes. In this situation there are two options you can choose from: first, take a short break and wait until the main lighting is back on so you can get a good exposure' or second, select a longer exposure and trying to randomly capture a shot with the strobes firing. Generally, I choose the second option, simply because a happy accident is always better than not getting any shots at all.

6.8 *The psychedelic band The Night Beats at the Seaholm Power Plant for the Austin Psych Fest. The house lights went dark and the only light source was a flashing strobe, so I slowed my shutter speed way down and slowly zoomed my lens in as the strobes flashed, with each flash recording a distinct image. This resulted in a very cool psychedelic effect that is perfect for the band's image. Taken with a Nikon D5100 with a Sigma 17-70mm f/2.8-4; ISO 100 for 1.6 seconds at ƒf2.8, spot metering.*

LASER LIGHTS

One thing to be aware of when shooting concerts is to watch out for laser lights. Although laser lights look very cool to both the audience and when captured in a still frame, lasers can damage your camera's sensor if they hit the sensor at the right angle. The intensity of the laser light, coupled with the focusing power of the lens and the high sensitivity of shooting at low light, can overload the pixels and render them useless. Although this is a very rare occurrence, there have been a few documented cases, so it's best to be aware that this can happen when shooting any events where lasers are being used.

6.9 *Although lasers look cool, you do run the slim risk of damaging your camera's sensor, so proceed with caution. Your best bet is not to use slow shutter speeds while laser lights are being used. James Hetfield from Metallica at the AT&T Center in San Antonio, TX. Taken with a Nikon D700 with a Nikon 28-70mm f/2.8D at 56mm; ISO 1800 (Auto-ISO) for 1/200 at f/2.8, spot metering.*

Backlighting is another lighting that you will find yourself dealing with pretty consistently when photographing these larger concert events. Backlighting is a double-edged sword; while it can ruin an image in some aspects, it can also be used creatively to add an artistic edge to some of your photos. Backlighting can cause you to lose contrast in your subject, but it can also be used to create silhouettes, add a rim light to the subject, and introduce creative lens flare into your shot.

The key to controlling backlighting is knowing where to take your exposure meter readings from and how to properly compose the image to get the light in the right spot. Using spot metering is the best way to meter when dealing with backlight.

To create a silhouetted image of the performer, take a spot meter reading of the brightest area of the scene and base the exposure settings from that reading. This is a good way to create a dramatic image by very simply underexposing the subject.

6.10 *For this shot of Gavin Rossdale of the band Bush, I aimed my spot meter at one of the lights, locked in the exposure, and recomposed and shot, resulting in this silhouette shot. Taken with a Nikon D300s with a Sigma 17-70mm f/2.8-4 at 25mm; ISO 200 for 1/320 at f/2.8, spot metering.*

To add a rim light to the performer you should compose the image so that there's a light source behind the performer. The effect of the light will be seen as a corona around the subject. You can use the rim light in two ways: to highlight a silhouette or to augment a normal exposure. To highlight a silhouette, follow the instructions in the previous paragraph and meter at the brightest point in the scene, having the light source behind the subject will create he rim light. To add a rim light to a normally exposed image, simply spot meter directly from the subject. I usually meter from the focus point.

6.11 *For this shot of Britt Daniel of the band Spoon I metered my exposure from the brightest spot. The lights were hitting him just at the right angle to outline his profile. Taken with a Nikon D700 with a Nikon 28-70mm f/2.8D at 52mm; ISO 1800 (Auto-ISO) for 1/200 at f/2.8, spot metering.*

Lens flare is one of my favorite effects to add to an image. It looks really cool, adds a cinematic effect to your shot, and is very easy to do. All you need is a bright light source aiming toward the lens; a strong white light is the best. The cause of lens flare is light being reflecting and scattered by the elements of the lens. Having the light source shine directly into the lens or placing a bright light source just outside of the edge the corners of the frame will increase the amount of the lens flare. Removing your lens hood will also help to increase the likelihood of creating lens flare in your shots.

6.12 *The bright spotlights shining directly into the lens add a cool effect of lens flare. This makes the image stand out from the rest. Johnny Wickersham of Social Distortion at Austin City Limits Music Festival 2011. Taken with a Nikon D700 with a Nikon 28-70mm f/2.8D at 28mm; ISO 200 for 1125 at f/5.6, spot metering.*

A lot of the technique of shooting with these elaborate lighting setups has to do with positioning yourself in certain ways in relation to the lights and the performers. Not only should you be paying attention to what the performer is doing, you should also be watching the background and the lights. Knowing where your light sources are helps you to control the effect of the light source on your subject.

Maneuvering yourself so that the performer blocks the light, or conversely shooting from an angle that allows a certain light source to shine at your lens, gives you a semblance of creative control over the lighting.

6.13 *Here I positioned myself so that the light showed through between the head and the microphone of Jim James of Monsters of Folk. This allowed the light to take on an ethereal glow. Taken with a Nikon D700 with a Nikon 28-70mm f/2.8D at 62mm; ISO 200 for 1/320 at f/3.5, spot metering.*

The vast number of lights in the stadium or arena scene, accompanied by the fact that any number of the lights will be at different luminosities and may or may not be shining into your lens, means that Matrix or Evaluative metering will be effectively rendered useless. Because the metering system reads the light values from the whole scene, all of the flashing and blinking confuses the metering system, which makes getting a consistent exposure reading next to impossible.

6.14 *The number of different light sources in the scene can be real trouble for Matrix or Evaluative meters, so sticking with a spot meter is recommended for most applications. David Yow of the Jesus Lizard at Austin Music Hall. Taken with a Nikon D700 with a Nikon 28-70mm f/2.8D at 62mm; ISO 3200 for 1/250 at f/2.8, spot metering.*

Spot metering ignores all of the other light in the scene except for that one single spot. Since the spot is tied to the active focus point, this is the best way to be sure that you are getting an accurate reading for the subject.

One setting I recommend staying away from is any automatic focus-point selection settings, such as Nikon's 3D-Tracking or Canon's Predictive AF. As with the metering system, the flashing lights of different colors make it difficult for the camera's focusing system to select the proper focus point. Having exact focus is very important, so in order to have complete control over your focus point, using the setting where you select only one AF point is very important. I also recommend using continuous AF, so that when the performer moves slightly the camera will continue to focus on that spot.

For exposure control settings most photographers prefer to shoot in Manual exposure mode. This will allow you to control you exposure exactly. You will need to keep a close eye on your exposure meter and check your histogram from time to time to be sure you are getting your exposures within a good range.

Oftentimes, however, I will use Shutter priority. This allows me to set my shutter speed to freeze motion and frees me up from constantly making exposure adjustments. I also use Auto-ISO, which adjusts the ISO for me to keep the images as low in noise as possible at any given moment. Not having to constantly adjust my exposure settings allows me to focus on composition more closely.

Tip: If the performer is wearing a lot of white you will need to adjust your exposure by underexposing at least one stop from the metered value.

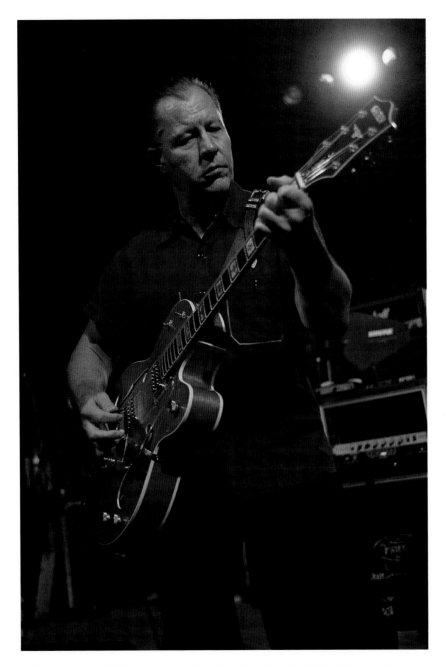

6.15 *Using Auto-ISO allows me to get nice clean shots when the light brightens up. The Reverend Horton Heat at Stubb's Waller Creek Amphitheater. Taken with a Nikon D700 with a Nikon 28-70mm f/2.8D at 28mm; ISO 360 for 1/200 at f/2.8, spot metering.*

CKSTAGE AND FSTAGE

Let me preface this by saying that live music photographers are seldom invited backstage to the green room or on the tour bus; th is where the performers go to prepare for their gig or to unwind afterwards. The last thing that most performers want is to be pestered by a photographer.

In the heyday of rock and roll in the 1960s and 70s it wasn't uncommon for music photographers to be welcome backstage and to document the festivities and even the sometimes mundane moments of life on the road. Photographers such as Bob Gruen, Jim Marshall, Annie Liebovitz, Robert Altman, and my personal favorite (although not quite as well-known) Glen E. Friedman were allowed personal access to a lot of famous acts because they were consummate professionals. They could be trusted not to take or release inappropriate images. This was their job and they lived by code of ethics, and if they betrayed those ethics they would never find work again. Take a look at the candid work of some these pho tographers and you will see into the inner personality of a performer that you can never capture during a performance.

In these days of easy access to high-quality digital SLRs, the pres- ence of the paparazzi, and the lack of ethics among photographers we are almost never invited backstage and are sometimes even shunned. I urge you to think before snapping photos backstage: be sure you are welcome; be courteous if you find yourself backstage; and most of all, be ethical.

CANDID PHOTOS

Candid photos are almost difficult to describe. Think of candid photographs as a carefully composed snapshot that offers a glimpse into the life of a performer that most people never see.

Being a musician myself, and having toured and worked with many different people in the business including bands, roadies, tour managers, and PR reps, I have been lucky enough to be included among the inner circle of some bands.

When taking candid photos the goal is to be a fly on the wall. Document the event like a photojournalist.

Although I don't recommend using a prime lens for most concert work, this is a situation where a fast prime such as a 50mm f/1.4 is

great tool to have in your bag. Green rooms, backstage areas, and even tour buses are usually relatively dim places, and a fast prime will allow you to capture all the light you can.

When shooting candids I always hearken back to the old days and remember looking at the work of the photographers that I mentioned at the beginning of the chapter. A lot of them shot black and white film, so I almost always envision my shots in black and white, and I will often set my camera to shoot in monochrome. Shooting RAW always retains the color information as well, which allows me to preview the images in black and white to make a better assessment of my shots.

Of course your artistic vision may be different than mine, so I encourage you to shoot in color.

7.1 *This is one of my favorite candids. This photo of Eugene Hütz, singer of the Gypsy punk ba in the green room at Stubb's Bar-B-Q in Austin, TX. Although it looks like Eugene is reprimandin "Ain't no party like a GB party!" after I had just uncorked a bottle of wine for him. Taken with a f/1.4; ISO 3200 for 1/30 at f/1.4, spot metering.*

At smaller touring festivals such as the Vans Warped Tour, the security isn't as tight, the bands are more relaxed, and you will often run into performers just walking around and enjoying the scene. Be polite and say, "Hey, do you mind if I snap a photo?" Don't get excited or starstruck and start snapping off shots paparazzi style; remember, at the end of the day these are people just like you. They are entitled to some privacy, and if they decline, just move on.

It's not often that bands allow photographers on stage, and to be completely honest shooting from the stage does not yield the greatest results for live-action music shots. Generally, you have to shoot from the side, which usually doesn't give you the best angle.

For candid-type shots, however, being on stage can give the viewer a feeling of what it's like to be in the shoes of a performer. First and foremost, make yourself inconspicuous. Just because the band lets you be on stage doesn't mean that you need to be part of the show. Fade into the background, and keep a low profile. At a recent festival I witnessed a photographer literally walking around on stage while the band was performing, and he was snatched off stage by the stage manager. The next day in the press tent a number of photographers who were shooting from the photo pit were complaining because they had some great shots of the band, but the photographer who was onstage appeared in all of their shots. Needless to say he was not a popular guy at the media trailer that morning.

The goal in candid photography from the stage is not so much to highlight the performer but to give the viewer a sense of feeling and of place, almost like a private connection to the performer.

7.2 In this shot I was wandering around the Warped Tour stop in San Antonio when I ran into my old friend David Tejas from the Krum Bums and Deryck Whibley from Sum 41. I said, "Hey guys, get together for a quick shot!" and this is it. Taken with a Nikon D700 using a Nikon 28-70mm f/2.8D at 28mm; ISO 1600 for 1/125 at f/2.8, matrix metering.

7.3 *This shot of rapper Lil B was taken at the Fader Fort by Fiat during SXSW 2011 in Austin, TX. The photo pit was overcrowded, and it was nearly impossible to get a shot with all of the shoving and pushing and camera lifting. Since I had backstage access, I squirmed my way out and headed backstage to try for some unique angles that other photographers couldn't get. I slinked my way behind the stage, and in between songs I managed to see this incredible lighting and pose and I nabbed this shot. Taken with a Nikon D700 using a Nikon 28-70mm f/2.8D at 28mm; ISO 200 for 1/400 at f/2.8, spot metering.*

PORTRAITS

Portraits are another situation that you may not come across a lot, but at times there are requests for them. Usually at festivals you can ask the band or performer's PR person or manager if you can snap a quick portrait. Most of the time these portraits are very informal, therefore I'm not going to go into any elaborate light setup techniques but just simple tips for quick and easy portraits.

Shooting portraits of musicians are pretty much the same as shooting portraits of anyone else. The key is in finding good lighting. Your best bet is going to be to find an area with nice diffused lighting and a simple uncluttered background.

If you're indoors you can't beat window lighting. This trick is used by professional portrait artists all the time, because it's easy and it looks good. Simply sit the person near a window, and the window softens the light yet it still appears directional, allowing you to capture soft shadows that create depth. One caveat, however, is don't use a window where the sun is shining directly in.

If you happen to be indoors and you have an accessory flash with a tilting head handy, you can use bounce flash to get a nice soft light. *Bounce flash* is exactly what it sounds like: you bounce the light from the flash from the ceiling or a wall to scatter the light rays to diffuse them.

When using bounce flash keep in mind the physics principle of the Law of Reflection, which states "the angle of incidence equals the angle of reflection." Angle the flash head so that the light bounces onto your subject's face. If the angle of the flash head is too low, the light will reflect behind the subject; if the flash head is angled too high, the light will be reflected in front of the subject.

Keep in mind that when bouncing flash you can lose up to two stops of light depending on the reflectivity of the surface you are bouncing from.

Tip: Dialing down the flash exposure compensation (FEC) will help your flash images retain a more natural look

Light from bounced flash will take on a color cast from the surface it is reflected from.

7.4 This shot of Grace Potter of Grace Potter and the Nocturnals was one of the few instances where I was actually requested to come into the dressing room and shoot some promo portraits of a pretty big star. In these situations you generally have a very limited amount of time with the performer, so you need to be ready to shoot when you show up. Rock stars aren't models, so be prepared to give a little direction if needed. I used a little bounce flash to brighten Grace's face. Nikon D700 using a Nikon 28-70mm f/2.8D at 45mm; ISO 1000 for 1/80 at f/2.8, matrix metering, iTTL flash –1EV flash exposure.

7.5 *Remember the angle of incidence equals the angle of reflection. Be sure that the flash head is angled in such a way that the light is bouncing onto your subject, not on front of or behind it.*

Bounce flash is a quick and easy way to get a nice indoor portrait, although I'd use window light over bounce flash if given the option.

Sometimes you will run into those once in a lifetime shots where you don't have a flash, you're inside where it's dark, and the lighting is terrible. In situations like that, crank up the ISO and go for it. It's always better to try for a shot and not get it than not to try at all. When all else fails, high ISO shots usually make for great black-and-white conversions; the noise gives the shots a gritty look that resembles actual film photos. I don't recommend using this technique as a crutch, but it can help bring an otherwise unuasble photo back to life.

When shooting outdoors try to find a shady area, underneath an overhang or veranda, near the door in a press tent, anywhere that isn't in direct sunlight. You can use the shade of a tree, but watch for *dappling*: this is where the sun shines in between the leaves and you get intermittent hot spots.

7.6 *I grabbed this portrait of Jeff Clayton, singer of the southern punk rock band ANTiSEEN right after they played a set at Red 7 in Austin, TX. There is almost no light in this venue at all, and I caught Jeff in the merch booth where there were a few clip-on work lights. Despite the brutal look of this photo, Jeff is a really nice guy. Taken with a Nikon D700 using a Nikon 28-70mm f/2.8D at 62mm; ISO 6400 for 1/80 at f/2.8, spot metering.*

7.7 This is a backstage portrait of Eugene Hütz of Gogol Bordello. I grabbed Eugene after the show and asked him to do a quick portrait. We went to one of the only places where there was light, which was a bare tungsten light bulb at the end of the hallway leading from the green room to the stage. I was sure to be quick about it, because after a performance the artists want to relax. I shot a quick burst of about five shots. Taken with a Nikon D700 using a Nikon 28-70mm f/2.8D at 62mm; ISO 6400 for 1/80 at f/2.8, spot metering.

7.8 *This is a quick portrait I shot of Justin Townes Earle just after a press conference at the 2009 Bonnaroo Music and Arts Festival. For a simple backdrop I used the white press tent and a wide aperture to smooth out the background. I positioned Justin so that the light was hitting him just from the side, adding an almost studio lighting quality to the shot. I added a little vignette in Adobe Photoshop to draw the eye onto the subject in the center of the frame. Taken with a Nikon D700 using a Nikon 80-200mm f/2.8D at 80mm; ISO 200 for 1/3200 at f/2.8, matrix metering.*

7.9 For this outdoor portrait of Irish rockabilly sensation Imelda May I found a nice shady spot near some soundproof booths at a festival. The booths were surrounded by haybales, which lended a rustic look to the shots. The light was very diffuse, which lends a nice softness to the skin; this is great especially when photographing women. Taken with a Nikon D700 using a Nikon 28-70mm f/2.8D at 70mm; ISO 200 for 1/1000 at f/2.8, matrix metering.

Direct sunlight is not the best type of lighting for portraits. In direct sunlight you can use a diffuser or reflector if you have one, but most concert photographers I know of don't usually carry one with them, although they do make small ones that you can easily fit in a camera bag. One final option for shooting in direct sunlight is to use *fill-flash*. This is using flash to fill in the harsh shadows caused by the bright sunlight. I would only use this as a last resort, because indirect lighting is always going to be your best bet.

ETIQUETTE

Etiquette. This is the one of the biggest problems I see in the industry today. A lot of the newer photographers just don't have it, or maybe they just don't know about it. We are all in the photo pit to do our jobs and to get our shots, but that doesn't mean we can't all be polite and even helpful to each other.

Being in the photo pit can be a hectic time: you're trying to get your shots, you're jammed in there with twenty other people, and you've only got three songs to get the shots! The truth is, if everyone relaxed a bit more, things would run so much more smoothly and the possibility of people losing their tempers would plummet.

8.1 *This shot was taken during SXSW at Rachael Ray's Feedback Party. Rachael is an avid photographer, and when she enters the photo pit she is the consummate professional!*

This chapter goes over some of the most basic forms of etiquette in the photo pit. Remember, we all have to work together, and a little kindness works wonders.

COURTESY TAP

This little tip goes a long way. Most photographers in the pit have their eye to the viewfinder. If you're making your way across the pit, give a quick tap on the shoulder to let the other photographer know you're behind them so you can get through. This works much better than just shoving your way through, which can cause tempers to flare.

CAMERA LIFTING

This is by far the most prevalent problem that I see in photo pits. In an effort to get a different angle the photographer lifts up the camera to grab a "hail mary" shot. More often than not there's another photographer right behind the "lifter" lining up a shot and, *bam!* all of a sudden there's another photographer's camera blocking the shot. If you've ever had a great shot lined up only to have this happen, you know how frustrating this can be.

The bottom line is that if you're going to lift your camera, go to the back of the pit *behind* everyone else. Lifting is just plain rude, and to be completely honest, it's a crap shoot on whether or not you'll even get a good shot.

8.2 *How many lifters can you spot in this photograph? Generally you won't see photo pits get this full, but even so, be mindful of your fellow photographers and keep the lifting to a minimum.*

A trend I've noticed in the past year or so are what I like to call the "super lifters." These are people who mount their cameras on a monopod, lift them up high in the air, and trigger the shutter with a remote. Once again, if you're going to go this route, move to the back of the pack.

Another issue I've seen with the monopod-mounted camera is that photographers sometime even lift the camera right into a performers face. This is *extremely* unprofessional and could get you expelled from the photo pit. It can also run the risk of a performer physically moving the camera, which may result in damage to the camera. Remember, a photo pass doesn't give you carte blanche to do whatever you want to get a shot.

8.3 *This technique takes lifting to the extreme. The photographer in this photo is standing off to the side, which is preferable, but in this case he is using a highly suspect technique and the chances of getting "great" shots using it are very slim.*

It's understandable that getting new and interesting shots is exciting, but you won't make many friends in the photo pit if you're a consistent lifter. Please be mindful of your fellow photographers.

CAMPING

A "camper" is a photographer who gets a great spot and just stays there. This not only blocks other photographers from getting any shots from that angle, but it also makes all of the camper's shots look the same because they're from the same angle. Varying the angle of your shots makes them more interesting.

If you get a great angle, get your shots and give the space to someone else; this, my friends, is known as good karma. Trust me; people remember when you help them out, especially when you work with them year after year at festivals or at large events.

Another version of the camper is the photographer who enters the photo pit, takes a few shots, and then stands there watching the show or in some cases even dances! The photo pit is for taking photos. If you've finished taking photos before the three songs is up, exit the photo pit to give more space to people who are still working. A photo pass isn't a front row concert ticket, it's a working credential and should be treated as such.

FLASH

As I've covered earlier, most of the time using flash isn't allowed. This point of etiquette doesn't concern the actual use of flash but is about having the flash on the hot-shoe of your camera. As in the case of a lifter, having the flash on your camera gets in the way of other photographers and makes it difficult for them to get their shots. Considering that flash isn't allowed anyway, take the flash off and leave it in your gear bag.

8.4 *This photographer is pulling a double faux pas, lifting with a flash. There were a number of other photographers behind this guy, and his consistent bad manners nearly caused an altercation.*

Taking off the flash is not only a courtesy to other photographers but also a safeguard for your gear: in a crowded pit you run a real risk of having the flash broken off at the hot-shoe.

CAMERA BAGS

If you've got a huge camera backpack, please don't wear it into a crowded pit. When room is limited a huge backpack makes it hard for other photographers to get around you. Stash your pack under the stage or under the barricade if you must have it with you.

If you have a regular camera bag, be sure to stash it out of the way as with the backpack. Most photographers aren't paying attention to what's under their feet as they're trying to make a shot, and having a camera bag in the middle of the photo pit can be a dangerous tripping hazard for you and other photographers. Not only that, there's also a good possibilty that your gear could be damaged.

Your best bet is to get a small shoulder bag and carry only the necessities. Not only does this save you from trouble with other photographers, you are much more flexible when not loaded down with a bunch of gear, making you lighter on your feet and better able to get different angles.

CAMERA PHONES

A lot of folks out there like to grab shots with their iPhones or camera phones, so that they can post to Twitter or Facebook real quick. If you feel you MUST take a photo with your phone, go to the back of the pit. Just like camera lifting, camera phones usually interfere with other photographers.

And for God's sake, don't EVER use an iPad in the photo pit!

8.5 *If you want to be the butt of the joke in the photo pit use this technique, shooting with an iPad.*

DRINKS, FOOD, AND SMOKING

Most of these are common sense tips, and a lot of you may wonder why they are even included. The simple reason is because I've seen these things happen, more often than I'd like to admit.

A lot of people like to bring drinks into the photo pit. Oftentimes there's a wait for the band to start, and it's nice to have something to quench your thirst. If you're in this situation, either finish your drink before the band starts, or when the band does start set your drink somewhere out of the way. DO NOT attempt to shoot while holding your drink; you will inevitably spill your drink, possibly ruining your camera, or even worse, another photographer's camera.

Smokers, be aware that photo pits are small and not everyone appreciates secondhand smoke. If you feel you *must* smoke in the photo pit, please be courteous and step off to the side. Extinguish your cigarette when the band starts, and as with drinks, NEVER smoke while you're shooting. You run the risk of burning someone. The last thing anyone should have to worry about when shooting is being burned by a cigarette.

Eating isn't as common as drinking and smoking, but I have seen people eating in the pit. Ideally people wouldn't eat in the photo pit, but this happens a lot at festivals where photograhers are running from stage to stage trying to catch every act they can and don't really have time to sit down and eat. As with drinks, try to finish before the band starts or put the food somewhere out of the way.

COMPOSITION AND FRAMING TIPS

COMPOSITION

Composition is one of the most important yet most overlooked facets of concert photography today. The key to making a great, dynamic photograph is making the composition work within the frame. Your general photography composition tips, such as the Rule of Thirds, using leading lines, and filling the frame, all apply in concert and live music photography just as they do in everyday photography.

It's very easy to get so caught up in the moment while trying to catch the performer's perfect pose that you forget your rules of composition, which often results in poor photos even though the subject is great. Being a good concert photographer requires a great deal of multitasking, and remembering to compose your images carefully is part of what a concert photographer must do while photographing any event.

Full Band

One of the must-have shots of most gigs is a full band shot (this isn't as important when it's a solo artist performing with a backing band). Getting the full band in a shot can be a very easy task or a very difficult task; it all depends on the size of the stage and how wide your lens is, but mostly it depends on the size of the stage. At a large concert venue even a relatively wide-angle lens of 24mm (or the crop frame equivalent), may not even be wide enough to capture the entire band, since they're likely to be spread out across the entire length of the stage. On the opposite end of the spectrum, in a small club the band members are more likely to be in close quarters, making it much easier to get the whole band in the shot even with a moderately wide to normal lens.

One thing to keep in mind when shooting the whole band is to keep the horizon level. This involves being sure that the stage area appears level in the frame. Many cameras' viewfinders have grid-lines built into them, although on some cameras this feature must be enabled.

When shooting the full band in large venues, capturing the background set is a great way to add some interest to the shot. A lot of national touring bands have elaborate lighting setups and back-drops especially designed for the band. Using an ultra-wide angle lens is usually the best option for this type of shot.

9.1 *This shot is of the Decemberists taken on the What Stage during the 2011 Bonnaroo Music TN. I used an ultra-wide setting not only to capture the whole band but also to get in the whole sign at the top of the stage, which really helps to set the scene. Photo editors look for this kind with stories about bands at specific events. Taken with a Nikon D700 using a Nikon 14-24mm f/. matrix metering.*

As I said earlier, in smaller venues like clubs it's much easier to get the whole band in the shot using a moderately wide-angle lens such as a 17mm setting on a crop sensor camera or a 24mm setting on a full-frame camera. One tricky thing to look out for is to try to make sure that nobody in the band is half obscured by another band member or blocked by a microphone stand or a guitar headstock covering his or her face.

My favorite way to get a full band shot is the straight-on approach. This is often possible at really large venues and stadiums. In medium-sized settings such as clubs and small amphitheaters this isn't often possible due to the restrictive size of the photo pit, so sometimes you'll have to use the sideways approach, where you shoot the band members from a side angle to fit them all in.

Singers and Rappers

Singers are often the main focal point of the band, since they are usually at the front and center of the action. They are also quite a dichotomy to photograph. If you have a singer who stands still most of the time, you can have a pretty easy time of it; if you've got a singer that is always on the move, this can pose some difficulties.

The main problem that you're going to run into when photographing a singer is having the microphone blocking the face. This is especially true when photographing rappers, who tend to bury their face into the microphone much more than singers do.

> *Microphones often cast ugly shadows on performers' faces, so keep an eye out for these shadows and try to avoid them.*

The real key to getting a good shot of a singer or rapper is catching that moment when the singer backs away from the microphone just enough that you can get his or her whole face in the shot. A photo where a singer's face is unrecognizable because it's half covered by their hands and a microphone isn't going to sell.

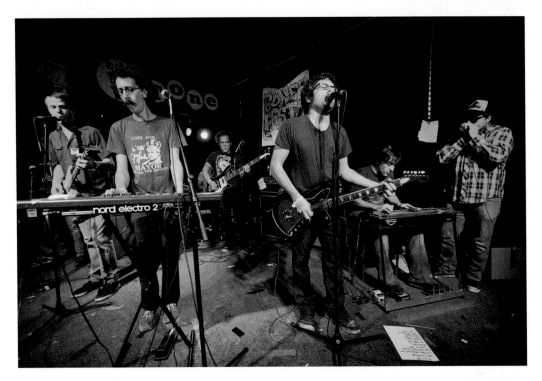

9.2 Here I shot straight on for this full band shot of the John Wesley Coleman Band at Goner Fest 7 in Nashville. Taken with a Nikon D700 using a Nikon 14-24mm f/2.8; ISO 6400 for 1/8 at f/2.8, spot metering.

9.3 I used a side angle shot to fit in all of the band members of the Eagles at the Austin City Limits Music Festival 2010. Taken with a Nikon D700 using a Nikon 35mm f/1.8; ISO 200 for 1/250 at f/1.8, −0.3EV spot metering.

9.4 *These two shots of Alison Mosshart singing with The Dead Weather were taken seconds apart. The image on the right, where you can see her face, is more likely to appeal to a magazine photo editor than the one on the left, where her face is obscured. Taken with a Nikon D700 using a Nikon 80-200mm f/2.8D AF-S; ISO 640 for 1/250 at f/8, spot metering.*

Basically, there are three distinct types of shots: close-ups, three-quarter length, and full body. These are similar to the types of shots you find in traditional portrait photography.

Close-ups are comparable to the headshot in the portrait photography world; the frame is filled with just the singer's face or head. To get these shots having a telephoto lens like a 70-200mm is generally necessary, although if you're in pretty close quarters, sometimes you can get away with using a standard zoom lens. These types of shots are great for capturing the mood of a singer and portraying his or her emotions with an up-close intimate feeling.

9.5 *Zooming in to 70mm allowed me to get this close-up of Social Distortion's frontman, Mike Ness. Taken with a Nikon D700 using a Nikon 28-70mm f/2.8 at 70mm; ISO 1100 for 1/80 at f/2.8, spot metering.*

When shooting close-up headshots, one thing to pay attention to are hands. If you can see the performer's hand or hands, try to include the whole hand in the composition. Another thing to try to avoid when shooting close-ups is the extreme "up the nose" shot. This often happens when the performer gets right at the edge of the stage and you're right underneath.

9.6 *Here's an example of the extreme "up the nose" shot. As you can see even seasoned pros get caught up in the moment and snap these types of shots. Taken with a Nikon D700 using a Nikon 28-70mm f/2.8 at 28mm; ISO 900 for 1/125 at f/2.8, spot metering.*

Three-quarter-length shots are your standard go-to shots, which capture the singer's head and the upper torso down to the waist or knees. These shots are close enough that you can make the image feel intimate, but you also capture more of the scene, such as the stage lighting and background. In addition, you can also get a sense of the performer's clothing, which can be as an important part of the artist's showmanship as anything else.

9.7 *A three-quarter-length shot of Mayer Hawthorne. This shot is a composed a little looser than your standard three-quarter shot to get in his raised hand, which adds character to the shot. Taken with a Nikon D700 using a Nikon 28-70mm f/2.8 at 70mm; ISO 320 for 1/160 at f/2.8, spot metering.*

9.8 *This shot of alternative rock crooner Morrissey taken at Bass Concert Hall in Austin, TX is a three-quarter shot taken horizontally, which isn't the norm. The negative space and loose crop adds some dynamic tension to the image. Taken with a Nikon D700 using a Nikon 28-70mm f/2.8 at 70mm; ISO 900 for 1/320 at f/2.8, spot metering.*

I like to save the full body shots for very dynamic performers. I often like to use a wide-angle lens not only to fit the whole performer in, but also sometimes to add a bit of perspective distortion to make the image a little more interesting.

9.9 *Karen O of the Yeah, Yeah, Yeahs is quite a performer. She's always moving and twisting, and therefore you can come out with some great shots, although she can sometimes be quite difficult to nail down. Taken with a Nikon D700 using a Nikon 80-200mm f/2.8 at 120mm; ISO 200 for 1/640 at f/2.8, matrix metering.*

Getting a good full-body shot requires capturing your subject at the peak of an action, whether it's a jump, or leaning way back while belting out a note. Photos of a performer just standing there doing nothing aren't very interesting, so try to capture some sort of movement to make your shots stand out.

Tip: Catching eye contact or a gesture from the singer adds a cool personal touch to a shot

9.10 *In this shot the pop sensation Colbie Caillat gives the camera a deadpan look. Photo editors love photos with eye contact. Taken with a Nikon D300s using a Tamron 17-50mm f/2.8 at 50mm (75mm equiv.); ISO 1600 for 1/80 at f/2.8, spot metering.*

9.11 *Singer Chris Cornell of Soundgarden has a serious set of lungs. When he belts out a scream he goes all out, as you can see by his pose here. Taken with a Nikon D700 using a Nikon 14-24mm f/2.8 at 24mm; ISO 3200 for 1/320 at f/2.8, spot metering.*

9.12 *I grabbed this full-body shot of Alison Mosshart with The Dead Weather just as she jumped up on the monitor to engage the crowd. Taken with a Nikon D700 using a Nikon 80-200mm f/2.8D Af-S at 185mm; ISO 200 for 1/400 at f/3.2, spot metering.*

Guitarists / Bassists

There is usually at least one guitarist and one bassist for most bands, so you will most likely end up with more shots with guitars in them than any other shots, especially considering most singers these days also play guitar.

Most guitar/bass photos are going to be of the three-quarter to full-length variety. Generally your three-quarter shots are by necessity going to be horizontally oriented, and your full-length shots will be vertically oriented.

The most common compositional mistake I see when photographing guitar players is cutting the headstock out of the picture. The headstock is an important part of the guitar and should be included in the shot. Cutting it off is quite the same as severing limbs in portraits, and as such should be avoided if at all possible.

9.13 *In this shot of astounding bass player Les Claypool I made sure to include the whole instrument; this almost forces you to compose by the rule of thirds, which usually results in more interesting photos. Taken with a Nikon D700 using a Nikon 28-70mm f/2.8 at 52mm; ISO 2500 for 1/125 at f/2.8, spot metering.*

One common problem that you often run into when photographing guitarists is getting the whole guitar from the headstock on back in focus when photographing from an angle because of the wide aperture that's usually necessary to use. If you have enough light you can try stopping down a bit, or you can change your angle and shoot more straight on to reduce the shallow depth of field problem. On a whole this isn't a very big problem, but there are situations where you may *need* to get the whole guitar in focus. For example, I often shoot gigs for guitar manufacturers of players who have signature or custom models. Having the brand name on the headstock and the details of the guitar are very important in situations like these.

Full-body shots often allow you to capture guitar players going at their most animated. These often make for the best shots. These shots are usually taken at relatively wide-angle settings and also work pretty well with ultra-wide lenses, if you can get in close enough to take advantage of the perspective distortion.

When photographing guitar players you often need to anticipate their motion. Fortunately, most music by nature is rhythmic, so feeling the beat and the rhythm can help you figure out when a guitar player might make a signature move. Pay close attention to a building tempo as well.

Sometimes you will run across bands that employ the upright or "dog house" bass. These are usually rockabilly acts, and sometimes traditional country or bluegrass bands use these types of basses as well. Although these instruments are quite large, they're pretty easy to photograph because bass players usually keep them relatively close to their bodies.

Tip: To avoid having all your shots look the same try shooting from different or odd angles.

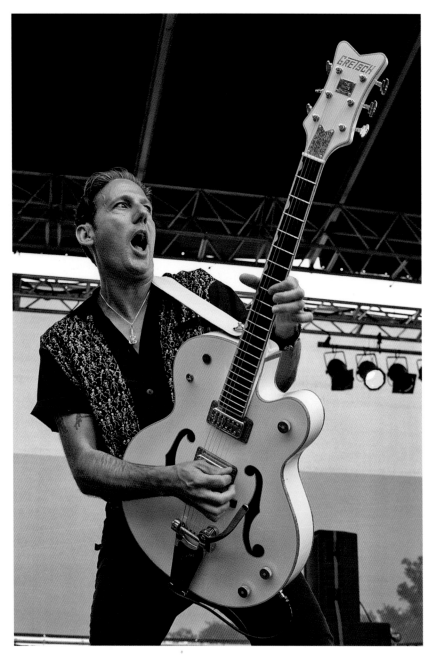

9.14 *This is a shot of Buzz Campbell, who is endorsed by Gretsch Guitars, with his guitar. These shots were taken for promotional use, so I stopped my aperture down to make sure the guitar headstock as well as the guitarist was in focus. Taken with a Nikon D700 using a Nikon 35mm f/1.8; ISO 200 for 1/100 at f/5, matrix metering.*

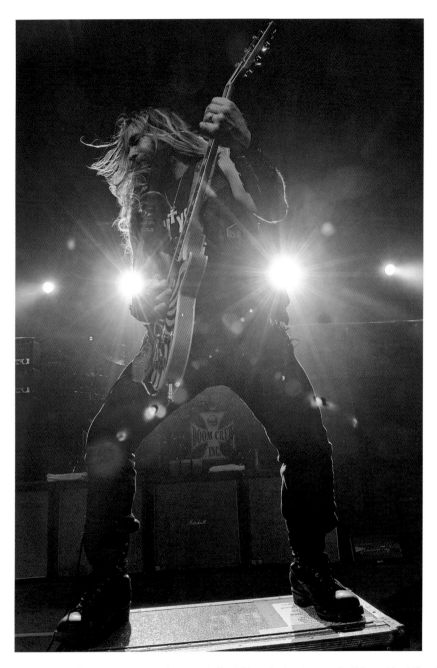

9.15 *Here's a full-length shot of Black Label Society frontman Zakk Wylde as he lays into a solo. Taken with a Nikon D700 using a Nikon 28-70mm f/2.8 at 70mm; ISO 1000 for 1/400 at f/10, matrix metering.*

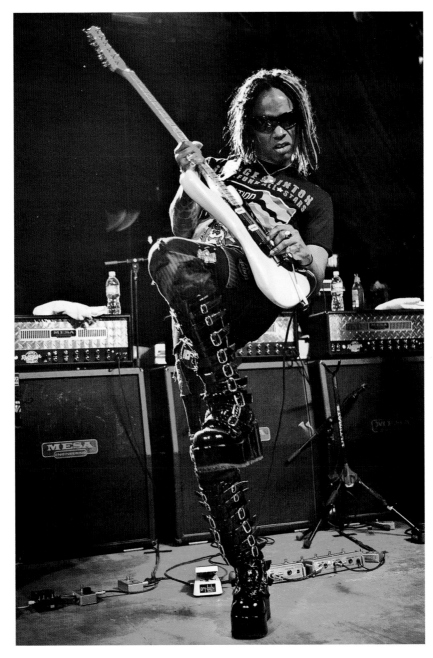

9.16 *I caught this shot of one of the P-Funk guitar players just as he peaked during a righteous solo. Taken with a Nikon D700 using a Nikon 28-70mm f/2.8; ISO 3200 for 1/160 at f/2.8, spot metering.*

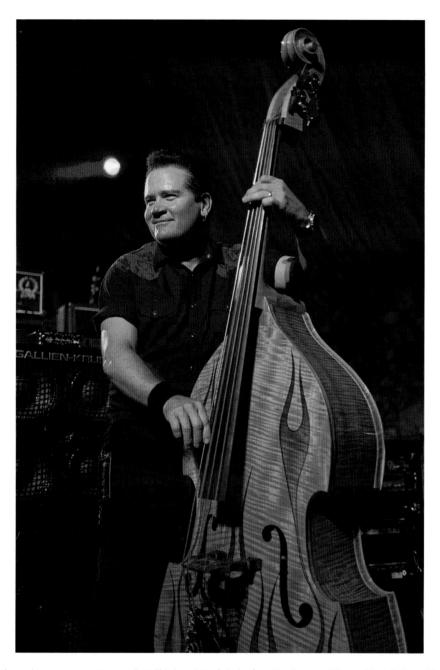

9.17 *Upright bass players are a pretty easy shot. This is a shot of Jimbo from the Reverend Horton Heat. Taken with a Nikon D700 using a Nikon 28-70mm f/2.8 at 50mm; ISO 1500 for 1/200 at f/2.8, spot metering.*

9.18 *Sometimes you will get that oddball bass player who gets a bit wild and crazy with the upright bass. When composing shots of guys like this, sometimes you just have to wing it as I did with this shot of Lee Rocker formerly of the Stray Cats. Taken with a Nikon D700 using a Nikon 50mm f/1.4; ISO 200 for 1/50 at f/1.4, spot metering.*

BANJOS, MANDOS, AND UKES

At times you may run into situations where you'll be photographing musicians playing instruments other than the standard guitars and basses. Banjos, mandolins, and ukuleles all fall into this category. When photographing these types of instruments follow the same principles as when photographing guitar players.

9.19 *Comedian Steve Martin is an accomplished banjo player as well as a genius comedian. He's seen here at the Bonnaroo Music and Arts Festival in 2010 with his band the Steep Canyon Wranglers. Taken with a Nikon D700 using a Nikon 80-20mm f/2.8D at 92mm; ISO 200 for 1/250 at f/2.8, matrix metering.*

9.20 . *Cathy Guthrie, the granddaughter of Woodie Guthrie, here plays ukulele in the band Folk Uke. Taken with a Nikon D700 using a Nikon 80-200mm f/2.8 at 155mm; ISO 200 for 1/2000 at f/2.8, matrix metering.*

Drummers

Drummers are the oft-overlooked personages of concert and live music pho-tography. They're up on a riser sitting higher than the rest of the band, and they are often hidden by traps, drums, and cymbals. Drummers also move a lot faster than the rest of the band members, even in bands that play relatively slow music.

Add to all this to the fact that they usually have the least amount of light on them. To put it simply, drummers are probably the most difficult band members to photograph.

9.21 *Drummer Kim Schifino, from the dance-punk duo Matt and Kim is always a fun drummer to photograph. She is extremely quick, however, so I tend to use a faster shutter speed than normal when photographing drummers like her. Taken with a Nikon D700 using a·Nikon 28-70mm f/2.8 at 62mm; ISO 200 for 1/320 at f/2.8, spot metering.*

The key to getting a successful shot of a drummer is to wait until the peak of the drummer's actions. Often times this comes during a break in the song or even at the end. Watch the drummer, and listen to the song to get a feel for the beat; this makes it easier to anticipate the action so you can catch it just at the right time.

9.22 *I timed this shot of Metallica drummer Lars Ulrich just as I knew a big break was coming in the song. It helps when you know the music, but if you listen to the song you can usually figure out where the break is going to be. Taken with a Nikon D700 using a Nikon 28-70mm f/2.8 at 70mm; ISO 1100 for 1/200 at f/2.8, spot metering.*

Keyboards / Pianos

Keyboards and pianos are among those odd instruments that it can be hard to effectively capture a performer playing. One of the determining factors is how close you can get to the performer and the instrument. I have found that my best shots of piano or keyboard players are from smaller venues where I've had the chance to get up close.

If you can't get very close to the keyboard player, leave the composition a little loose so that you can include the instrument. Framing in too close makes it difficult to see what the performer is actually playing.

9.23 *I framed this shot of Passion Pit's Ian Hultquist relatively loosely, not only to show the keyboards but also to include some of the light show in the background. Taken with a Nikon D700 using a Nikon 28-70mm f/2.8 at 70mm; ISO 2200 for 1/200 at f/2.8, spot metering.*

Getting up close and using a wide-angle lens really makes keyboard images stand out. I find most keyboard players are pretty cool with you getting close, presumably because they don't often get the same amount of attention that singers or guitar players do.

9.24 *I used an ultra-wide angle and an up-close perspective to get this off-the-wall shot of John Wesley Coleman's keyboard player Nathan Arbeitman. The stretched-out look caused by the perspective distortion adds a fun element to the shot. Taken with a Nikon D700 using a Nikon 14-24mm f/2.8 at 14mm; ISO 6400 for 1/80 at f/2.8, spot metering.*

Horns

The main thing about dealing with horn players is going to be microphone stands obscuring their faces. This is especially a problem when there's an actual horn section with three or more horn players all stacked up in a group. It's nearly impossible to take a shot where at least one of the players isn't being blocked by a microphone stand or by one of the horns.

9.25 *Being on the right side of the horn and shooting at an angle are the key to getting a shot of a horn player, such as this one of Charles Spearin of Broken Social Scene. Taken with a Nikon D700 using a Nikon 28-70mm f/2.8 at 70mm; ISO 5600 for 1/125 at f/2.8, matrix metering.*

Not all horn players use traditional microphones and stands. Some use mics that clip right on to the end of the horn, which makes getting an unobstructed shot much easier than when shooting with mic stands in the way.

9.26 *This is a shot of legendary jazz saxophonist Sonny Rollins, who has played with Miles Davis, Thelonius Monk, and Charlie Parker. Sonny uses a clip-on mic and wanders around the stage unobstructed by the band, which makes capturing images of him fairly easy.*

Usually a single horn player is pretty easy to capture. It's all about getting the right angle, just as when shooting singers you want to try to catch them when their faces aren't obscured. A 45-degree angle works pretty well for most horn players, although with trombone players you need to be sure you're on the opposite side of the slide or you may find it blocking your view.

GENERAL TIPS

This section covers some of the more common things to think about regarding composition when shooting concerts and live music events. These are some of the things to keep in the back of your mind while shooting. After a while, these things will become second nature and you won't even think about them, you'll just shoot it.

Foreground / Background

Often, especially when beginning this type of shooting, photographers get so intensely focused on the performers that they forget to pay attention to what's going on the background and foreground.

The front of the stage is often lined with monitors, which can make it difficult to get a good full body shot and oftentimes they just get in the way of your composition. On higher stages the monitors are more of a challenge to shoot around than on lower stages. Basically, the only workaround is to shoot tighter crops of the performers.

Sometimes, however, you just have no way around it, and the monitors are going to be in the shots. Having monitors in your shot is by no means a deal-breaker, but it's just something to think about when composing your shots.

9.27 *Although stage monitors can often hinder getting a clean shot, a lot of times the band uses them as a prop. This can be a real advantage when the stage is high and you're shooting from down low. This shot of Eugene Hütz of Gogol Bordello shows him using the monitor to reach out to the crowd. Taken with a Nikon D700 using a Nikon 80-200mm f/2.8 at 185mm; ISO 450 for 1/200 at f/2.8, −0.3EV, spot metering.*

Another very important thing to keep your eye on when composing is the background. As I mentioned earlier, sometimes as photographers we can get so focused on the subject that we forget to take the background into consideration. A badly cluttered background can ruin even a perfectly composed shot.

9.28 *The Red 7 in Austin TX has one of the most cluttered backgrounds of any place I've ever shot, not to mention the tough lighting situation. Taken with a Nikon D700 using a Nikon 28-70mm f/2.8 at 32mm; ISO 6400 for 1/200 at f/2.8, spot metering.*

Now, when I say cluttered I don't necessarily mean that the background has to be plain, but you want to keep an eye out for messy backgrounds with things like exit signs, roadies, cables, electrical conduit, etc. These types of things detract from your images, although sometimes they're unavoidable.

On the other hand, especially for large touring acts, there is often a background set. This can add to your images and allow you to help set the scene. If the background of your photo is busy with stage lights, this type of clutter can be OK, because lights are part of ambience of the scene. You can use these types of backgrounds to *add* interest to your images.

9.29 *Although this shot of Swedish indie-pop band Miike Snow has a cluttered background, it includes the band's backdrop as well as a sampling of the lighting, which conveys a sense of what being at the performance was like. Taken with a Nikon D700 using a Nikon 28-70mm f/2.8 at 48mm; ISO 560 for 1/60 at f/2.8, spot metering.*

9.30 *For this shot of John Mayer I framed him so that the monitor that was displaying him was behind him, so that the background of this shot is actually a close-up of his guitar. Taken with a Nikon D700 using a Nikon 28-70mm f/2.8 at 65mm; ISO 320 for 1/100 at f/2.8, matrix metering.*

When shooting festivals or smaller package shows there is often a sponsor or sponsors, companies who help put on the show by donating money and/or equipment. Often these sponsors hire photographers to shoot the shows. When shooting for a sponsor keep an eye out for banners, signage, and other promotional materials in the background and try to include these in the shot.

9.31 *This is a promotional shot featuring guitar player Matt Hole from Matt Hole and the Hot Rod Gang. I specifically shot this image loosely cropped to include the banner, which advertises the festival (Revival Festival) and the main sponsor (Gretsch). I also stopped down the aperture to get the background reasonably in focus. Taken with a Nikon D700 using a Nikon 35mm f/1.8; ISO 200 for 1/125 at f/5.6, spot metering.*

Capturing Action

To make your concert photos livelier and to help viewers feel like they were there, capture action. If you *really* want to capture the mood, catch musicians while they're doing something interesting: a guitar player laying into a blazing solo with his hair whipping around; a singer's kick; a rapper pumping his fist into the air——these are all good ways make your photos more interesting.

9.32 *I captured this shot of Sonic Youth's Thurston Moore just as he ripped off his guitar. Action shots appeal to people more than static ones. Taken with a Nikon D300s using a Nikon 28-70mm f/2.8 at 45mm (67mm equiv.); ISO 1000 for 1/320 at f/2.8, spot metering.*

Most of the time capturing these action shots will be off-the-cuff, and sometimes you won't even expect it coming. The bottom line is to expect the unexpected and be ready for almost anything!

9.33 *Nothing says action quite like catching a rocker in mid headbang! Taken with a Nikon D700 using a Nikon 28-70mm f/2.8 at 28mm; ISO 500 for 1/400 at f/5, matrix metering.*

Capturing action doesn't necessarily mean that the performer is doing something quickly or energetically. Even uncommon or slow, deliberate actions are enough to distinguish your image from the norm, as evidenced in figure 9.34.

9.34 *Dave Navarro of Jane's Addiction takes a smoke break between songs. Even though there was a break in the energetic performance of the show, the slow deliberate action combined with the perfect lighting makes this an interesting shot. Taken with a Nikon D700 using a Nikon 28-70mm f/2.8 at 45mm; ISO 2500 for 1/320 at f/2.8, spot metering.*

Band Interaction

Being in a band is like being in a close family, and band members will communicate with each other on stage and play off of each other. Catching these moments is a great way show the camaraderie that exists between band mates.

9.35 *Robert Trujillo and James Hetfield of Metallica share a moment on the Death Magnetic tour. Taken with a Nikon D700 using a Nikon 28-70mm f/2.8 at 42mm; ISO 1400 for 1/200 at f/3.2, spot metering.*

Sometimes the singer will saunter up to the guitar and tell a joke, causing the band members to smile, or you may catch two guitar players playing dueling leads. The bass player and the drummer are usually pretty tight, being the rhythm section, and will often look at each other for cues. Keep your eyes open for the little things, and your photos will tell a more intimate story of the bands.

9.36 *Here I catch Dave Mustaine and Chris Broderick of the metal band Megadeth in a dual solo. Taken with a Nikon D700 using a Nikon 28-70mm f/2.8 at 28mm; ISO 720 for 1/250 at f/2.8, spot metering.*

Audience Participation

Since the audience is the band's bread and butter, they often like to reach out to the crowd to connect with their fans. This is usually a great way to get a cool up-close shot of a performer and is an excellent opportunity to show the energy of the show.

One caveat of this is that when a performer breaks the stage boundary, both fans and photographers tend to get a little out of control. Try to keep a cool head when this happens. People often get very pushy and will start jamming their cameras in front of you and into the performers face. Relax. Cooler heads prevail, and you'll get your shot.

9.37 *Weezer's Rivers Cuomo can always be counted on to hop out into the crowd. Taken with a Nikon D700 using a Nikon 28-70mm f/2.8 at 45mm; ISO 2500 for 1/320 at f/2.8, spot metering.*

Doing a little research by inquiring at concert photography groups on the Internet can often clue you in to if and when a performer might head into the crowd. For example, Thomas Mars, the singer from Phoenix, usually hops into the crowd near the end of the third song, and he usually comes from stage left. How do I know this? I've photographed the band numerous times (of course this may change on the next tour). Concert photography groups like the ones on Flickr are full of useful information that can be gleaned from photographers who may have already shot the band on the current tour.

9.38 *You can always count on Eric Davidson of the New Bomb Turks to take to the crowd. Taken with a Nikon D700 using a Nikon 28-70mm f/2.8 at 25mm; ISO 6400 for 1/30 at f/2.8, spot metering.*

Crowds and Spectators

The crowd is an integral part of the show, and to be honest, if it weren't for the crowd most of these bands wouldn't even be performing. For the most part crowds get pretty excited when you turn the camera on them, and you can get some pretty wild shots.

Personally, I always have fun with the metal and punk crowds. It's always great to catch someone crowd surfing or stagediving. These types of crowds tend to be more animated than a crowd at a jazz concert.

9.39 *I took this shot of a crowd surfer at the Mayhem Festival just as security was grabbing this guy over the barrier. Taken with a Nikon D700 using a Nikon 14-24mm f/2.8 at 14mm; ISO 200 for 1/400 at f/14, spot metering.*

I take two separate approaches when shooting the crowd: I go full-on ultra-wide to get the whole crowd, and at times I will isolate smaller groups or even single people. When shooting crowds with an ultra-wide be aware that to get a shot that makes an impact you need to get *close*. In figure 9.39 it may look like the guy is a few feet away from me, but in reality I was only about a foot away and nearly got my lens kicked because his right foot is right underneath the camera. Be careful in these situations.

9.40 *I snapped a shot of these two little guys enjoying a show at the Austin City Limits Music Festival. I got in real close with my fisheye lens for a wacky perspective. Taken with a Nikon D700 using a Nikon 16mm f/2.8 fisheye; ISO 3200 for 1/20 at f/11, matrix metering.*

Check with the venue ahead of time on their crowd shooting policy. Some venues do not allow photographers to shoot the crowd for liability reasons.

Concert photography isn't all cut and dry; there are a lot of different techniques you can employ to make your images stand out from the guy right next to you. Let's face it; with 20 photographers jammed into the same little space, chances are a lot of your shots are going to look similar. What you need to stand out from the pack is to use a little creativity.

Slow-Sync Flash and Shutter Drags

Most of the time, you're not allowed to use flash. In small clubs, especially rock and roll dive bars, they usually don't have any rules about using flash. I want to preface this by saying, *use this technique sparingly*. I play in a number of bands, and although we are quite popular we aren't at the *"three songs, no flash"* level. If someone wants to photograph us, great, we're all for it. But, having a flash popped in your face for a whole set is very distracting, and it gets annoying pretty quick. Yes, I have asked photographers to stop using flash.

That being said, in a very dark club using a little bit of flash can help. Unfortunately, once you pop that flash the ambience of the scene is gone. The lighting looks plain and flat. To cure this photographers do what is known as a *shutter drag*. What this means is that you set the shutter speed for a longer amount of time than it needs to make a flash exposure. This allows the ambient light to be recorded as well. Most cameras have an automatic setting for this called Slow-Sync. I hesitate to do this, because the camera usually sets the shutter speed much too long and the photos come out looking like a blurry mess (which sometimes happens anyway).

When doing a shutter drag, I usually set the exposure manually: I set the aperture wide open, and I use a shutter speed anywhere between 1/30 and 1/4 of a second. Rarely do I use a longer shutter speed unless I'm really going for an exaggerated look. I set my ISO from 400 to 800, depending on the ambient light. Setting the ISO a little higher allows you to fire the flash at a lower power, allowing for shorter recycle time and less battery drain.

This technique usually requires a bit of experimentation with the shutter speed. It's not an exact science by any means, but it yields some interesting results. I also recommend angling the flash head up and using a bounce card to soften the light a little.

9.41 *Using flash and a shutter drag allowed me to capture this vivid shot of Sammy McBride, lead singer of the punk band Fang. Taken with a Nikon D700 using a Nikon 28-70mm f/2.8 at 28mm; ISO 400 for 1/4 at f/3.2, spot metering.*

Lens Flare

Lens flare is caused when a bright light source shines directly into the lens. The light is reflected by the multiple glass elements and causes artifacts to appear in the image. Generally, lens flare is to be avoided, and for this reason most lenses come with a lens hood, but occasionally intentionally including lens flare can add a cool element to your photos.

Each lens produces a unique light flare pattern, which depends on the number and grouping of the elements. Some lenses make flare patterns that are more "attractive" than others, but that's a very subjective term.

9.42 *In this photo of Kyp Malone of TV on the Radio, I positioned the spot light so that it shined directly in my lens to produce flare. Taken with a Nikon D700 using a Nikon 28-70mm f/2.8 at 34mm; ISO 360 for 1/125 at f/2.8, spot metering.*

Lens flare is reduced by stopping down the lens, so shoot wide open if you're trying to introduce lens flare into your image.

Silhouettes

Silhouetting is another technique that can give your images a distinctive look. The subject appears in deep shadow and is highlighted by rim lighting. This technique works best when there's heavy backlighting in the scene. If the performer has a bright spotlight shining directly on them from the front, a silhouette is going to be pretty hard to accomplish. With backlighting this is a pretty easy technique to do: simply expose for the brightest area in the scene.

9.43 *Metering on the bright spotlights in the background allowed me to capture Local Natives' Taylor Rice as a silhouette. Taken with a Nikon D700 using a Nikon 28-70mm f/2.8 at 28mm; ISO 200 for 1/250 at f/8, –0.3EV, spot metering.*

Selective Focus

Using a shallow depth of field and focusing on details is an easy way to create more creative and artistic images as opposed to your standard concert shots. There are no real rules as to what you should focus on, but some of the things to consider are guitar headstocks, close-ups of hands either fretting or picking, or any number of other details.

The key is to shoot wide open, using a wide-angle to standard focal length and getting a little closer to the subject. Using a longer telephoto lens will allow you to get a more shallow depth of field from a longer distance.

9.44 *I used a shallow depth of field for this close-up of surf guitar legend Dick Dale's iconic Fender Stratocaster. Taken with a Nikon D700 using a Nikon28-70mm f/2.8 at 70mm, ISO 3200 for 1/125 at f/2.8.*

ITING YOUR PHOTOS

FINDING THE KEEPERS

Once you're done shooting the show and you get your images downloaded on your computer, it's time to get down to editing. The first thing you want to do is eliminate any of the images that are unusable. In these days of high megapixel counts and RAW files, the files sizes can be pretty large, so getting rid of the images you know you definitely will not be using will save you a lot of hard drive space.

There are a number of ways you can go through images, with lots of different programs. Each photographer has his or her own preferences. Some prefer to use Adobe Lightroom or Apple's Aperture. My personal preference for scanning through my images is Adobe Bridge, though I am currently trying out Photo Mechanic, which was recommended to me by a number of other live music photographers.

The first thing you want to look for is severely under- or over-exposed images. RAW files are extremely flexible, and you can often save some detail in improperly exposed shots, but there is a limit. These images are usually pretty easy to spot. Delete the files.

The next thing to look for isn't always readily apparent; focus. Most of the time you will be able to recognize when an image is very out of focus, but sometimes your focus point may have been slightly off, or the performer may have moved too quickly. Out of focus images should be trashed as well.

The third thing I look for are shots that are very similar in nature. This usually happens when firing off a burst, but if a performer tends to have the same pose throughout the set, you'll find you can get a lot of shots that are fairly similar. If you've got a dozen images of nearly the same pose, pick one or two and delete the rest.

Once I have decided on the keepers I rename the files. The naming convention can be any number of things. Photo agencies usually have a specific naming convention that they like you to follow. My naming convention is as follows: BandName_jdt_001.jpg.

IPTC METADATA

IPTC stands for International Press Telecommunications Council. This is the governing body that sets the standards for news exchange the world over. If you plan on marketing your images or if you are licensing your images through an agency, plan on adding IPTC metadata

ur images. The IPTC metadata is very important, because this
ere you add information about your images that allows your
es to be searched for content by text. If you don't have the
ent information your images may never find their way into the
s of the people who may want to license them.

Edit Metadata Template

Template Name: Metadata

Choose the metadata to include in this template:

▼ − **IPTC Core**
☑ Creator	J. Dennis Thomas
☐ Creator: Job Title	
☐ Creator: Address	
☐ Creator: City	
☐ Creator: State/Province	
☐ Creator: Postal Code	
☐ Creator: Country	
☐ Creator: Phone(s)	
☑ Creator: Email(s)	deadsailorproductions@gmail.com
☐ Creator: Website(s)	
☑ Headline	Monarch Box performs live at Stubb's BBQ
☑ Description	Monarch Box performs live at Stubb's BBQ in Austin TX during the 2011 SXSW Music C
☑ Keywords	SXSW, music, performance,
☐ IPTC Subject Code	
☐ Description Writer	
☑ Date Created	03/17/2011
☐ Intellectual Genre	
☐ IPTC Scene Code	
☑ Sublocation	Stubb's BBQ
☑ City	Austin
☑ State/Province	TX
☑ Country	USA
☐ ISO Country Code	
☐ Title	
☐ Job Identifier	
☐ Instructions	
☐ Credit Line	
☑ Source	J. Dennis Thomas
☐ Copyright Notice	
☑ Copyright Status	Copyrighted
☐ Rights Usage Terms	

▶ ☐ **IPTC Extension**
▶ ☐ **Audio**
▶ ☐ **Video**
▶ ☐ **DICOM**
▶ ☐ **Mobile SWF**

⚠ Only checked properties will be added/changed to this template.

Properties selected: 12

(Clear All Values)

Any of the standard photo-editing programs such as Adobe Photoshop and Lightroom, Apple Aperture, and Photo Mechanic allow you to easily add IPTC metadata to the image file. Different photo agencies have their own criteria about which fields need to be entered with information. There are 11 fields in the IPTC Core that I feel are absolutely necessary to be filled out. These are:

- **Creator** – This is where you put your name as the person who created the file.

- **Headline** – This is a concise description about what the image is about. This should be brief. For example, John Smith performs live in Austin, TX. Always use the present tense and use the active voice of the verb.

- **Description** – This is a more detailed account of what the photo is about. For example, John Smith performs live at the Paramount Theatre in Austin, TX for the Austin Orphans Benefit show. Be sure to use proper grammar, capitalization, and punctuation.

- **Keywords** – These are single- or two-word descriptions about what the photo contains or is about. Examples include: music, performance, guitar, concert, singer, and things of that nature. Don't use sentences here.

- **Date created** – Enter the date that the image was shot.

- **Sublocation** – This is where you enter the name of the venue.

- **City**

- **State/Province**

- **Country**

- **Copyright notice** – This is where you enter the name of the copyright holder. I usually have mine listed as J. Dennis Thomas / dead sailor productions. You can also just list your name.

- **Copyright status** – You have three options: Copyrighted, Public domain, Unknown. Obviously you want to select Copyrighted unless you want to make your images available for free, in which case you can select Public domain.

Tonal Adjustments and Color Correction

Most images are rarely perfect straight out of the camera and usually need some tonal adjustments and tweaking of the colors. After editing for the keepers, renaming, and entering the meta-data. Open up the files that you want to work on with your favorite RAW converter. If you're going to be doing concert and live music photography you should have a good RAW Converter, because as a concert photographer you really should be shooting RAW . There are a lot of different software options out there; Adobe Camera RAW (in Photoshop), Adobe Lightroom, Apple Aperture, ACDSee Pro, Photo Mechanic, and more.

I'm not a proponent of any one system; I just use what works for me and what I'm comfortable with, which at this time is Adobe Camera RAW. I'm not going to go into specifics on each type of software, so I'm going to keep this pretty generalized. One thing is for certain, each of these RAW converters have tools that enable you to make changes to the White Balance and some sort of exposure adjustments for tonality.

The first thing to do is asses the image's exposure. Do this not only by looking at the image but by looking at the histogram. The histogram in your RAW editor is likely going to be more detailed than the one that you can view on your camera monitor and will reflect changes in real time, so pay close attention to it. This will tell you whether or not your shadows and/or highlights are clipping, or if one of the RGB channels are clipping as well.

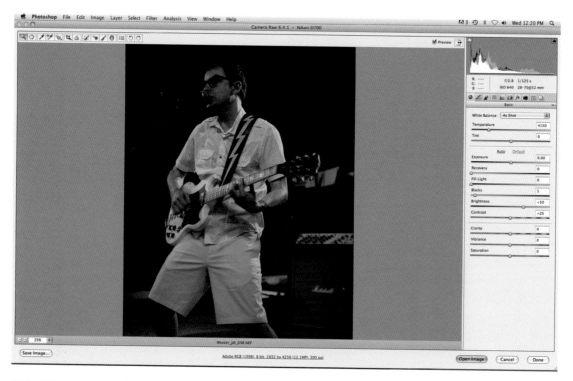

10.2　*Taking a look at the histogram in this image I see that the image is a bit underexposed.*

After assesing the exposure, it's time to determine what needs to be done. You will most likely need to reign in the highlights a little as well as bring up a bit of shadow detail. You can do this in any number of ways: by doing a Levels or Curves adjustment, or by using any number of sliders in your RAW conversion software. Pull back the exposure slider a bit if there are out of control highlights. I use this method because the highlight recovery sliders often take out too much contrast and can even add a grey tint sometimes. To brighten up the shadows the fill light slider (or equivalent tool) usually works wonders.

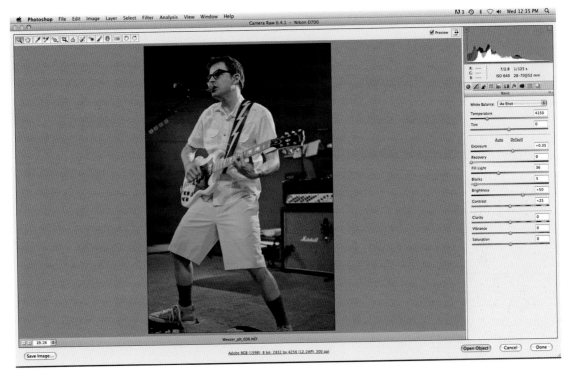

10.3 *I adjust the Exposure slider to bring up the highlights a bit. Using the Fill Light slider allows me to bring out detail in the shadow area without causing overexposure in the highlight areas.*

After doing your tonal adjustments, next it's time to to do *color correction*. I use this term lightly because unlike when shooting portraits, landscapes, or some other type of traditional photography, there usually isn't a *correct color*. Probably the best and easiest tool to use for color correction is the White Balance tool. This can be a trial-and-error method. Start by clicking around on neutral colors like a black, white, or grey area. By clicking around you will see the different color changes and select the one you like. You can always make minor adjustments as well by using the color temperature and tint sliders. For more about White Balance see Chapter 2.

Tip: You can use the lens correction module to add a slight vignette to some images, which draws the viewer's eye into the subject.

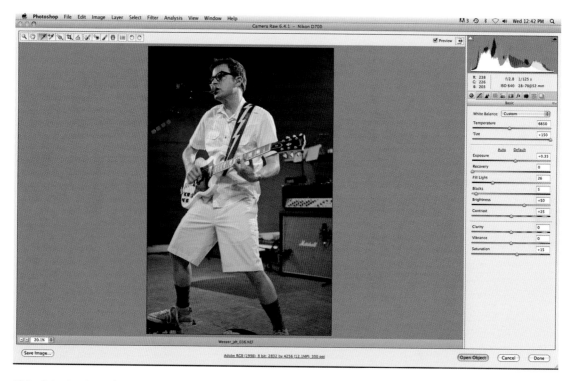

10.4 *Selecting the eydropper tool and clicking on a neutral area changes the white balance drastically, which gives me a more natural skintone while retaining the colors of the stagelights. I also increase the saturation a bit to make the colors "pop."*

CROPPING

Sometimes you will come across images that need to be cropped. There are photographers out there who are staunchly against cropping, but I'm not one of them. Oftentimes the 2:3 aspect ratio of the camera sensor leaves a lot of blank space around the performers. Although I recommend filling the frame, sometimes it's not possible without cutting something important out of the composition. I generally use standard ratios when I crop. I usually find that when the 2:3 ratio doesn't work in camera, a 4:5 ratio works perfectly. Sometimes a 3:4 ratio is needed, and rarely I use a 16:9 cinematic ratio for ultra-wide shots. The reason why I don't fret about cropping my images is because most photo editors crop your images to fit their needs anyway. If the image looks better cropped then do it.

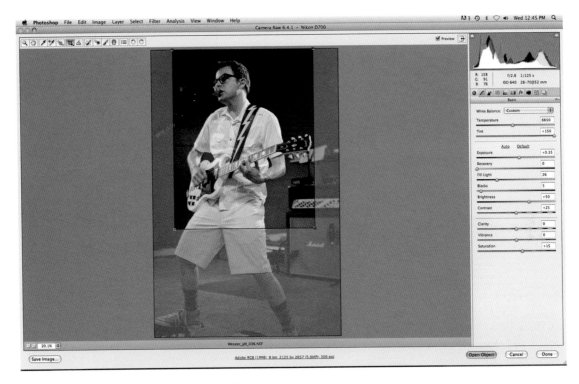

10.5 *I'm not 100% happy with the composition of the image so I go in and crop.*

NOISE REDUCTION

In Chapter 2 I discussed ISO sensitivity and noise. As you may recall, as the ISO sensitivity is raised the camera amplifes the signal from the sensor, which in turn amplifes extraneous electrical signals from the sensor and results in noise. Most cameras have some built-in Noise Reduction (NR), but when shooting RAW, unless you use your camera's proprietary software, like Nikon Capture NX 2, no actual noise reduction is applied. This is a good thing. Most in-camera NR is ham-fisted in it's approach, which usually results in overly soft-looking images.

Noise isn't a new thing. Before digital photography concert photographers used high-speed film or *pushed* slower film when processing to achieve more light sensitivty. High-speed films had larger particles of silver halide (the light-sensitive element in film), which resulted in images that had a grainy look. We called this *film grain*. It was a necessary evil if you wanted to do low-light photography, therefore it was an acceptable part of photography.

The point I'm getting at is that film grain and noise are very similar, and that some level of noise is to be expected, and in fact noise gives your images a more

natural quality at lower levels. Over-processing to get rid of noise can often make your images look worse.

Similar to how different brands of film had different grain qualities, different cameras have different amounts of noise at comparable ISO settings. So whether you need to use some sort of noise reduction or not is highly dependent on your camera (and your personal preferences).

Most RAW converters have some sort of noise reduction module built in, or you can use Adobe Photoshop plug-ins or standalone programs as well. The Adobe Lightroom 3 noise reduction is very good, as is Nik D-fine and Noise Ninja. D-fine and Noise Ninja are available as either plug-ins or standalones.

If you remember back in Chapter 2, I noted how there are two different elements that comprise digital noise, *chrominance* and *luminance*. Chrominance refers to the color of the specks of noise, and luminance refers to the size and shapes of the individual specks. All of this is increased as the ISO sensitivity is set higher.

10.6 *At this stage I determine that there is some noise in the shadow areas where I brought up the levels using the Fill Light slider. I use a fairly high setting on the Color slider, and push up the Luminance slider just enough to tame the grain a little. I add a little sharpening to compensate for the softness that Luminance noise reduction can bring to an image. It's best to do this step while viewing the image at 100%.*

Chrominance noise is by far the most unnatural-looking type of noise (when compared to film grain) and can be more detrimental to image quality than luminance noise, which looks more like traditional film grain. Chrominance noise is generally comprised of colored specks that appear to be mostly magenta, blue, and green. This type of noise is more prominent in the shadow areas.

Luminance noise appears as a grainy type of speckle in the image. While it can be troublesome when printing large images for display, as a whole it's not quite as unnattractive as the chroma noise can be. For most magazine print uses, luminance noise isn't an issue at all, so keep that in mind when doing any type of noise reduction.

Most of the current noise reduction software options deal with each type of noise separately and have separate controls that allow you to fine-tune the separate adjustments as well. Some software such as Nik D-Fine also use a control point technology that allows you to pinpoint where the noise reduction is applied to. This is a great feature considering most noise appears in the shadow areas, and oftentimes applying noise reduction reduces the detail in the brighter areas.

10.7 *Overdoing the Luminance noise reduction gives the image a blurred quality that looks unnatural.*

In my expereience the best way to approach noise reduction is to use chrominace noise reduction with moderate to high settings. Reducing chroma noise has almost no detrimental effect to your image quality. When using luminance noise reduction, on the other hand, a very light touch is required. Lumnance reduction reduces the detail in your image at a very high rate, and it's easy to overdo it, leaving your image looking smeary or *plastic-y* as I've heard a lot of people call it.

BLACK AND WHITE CONVERSION

Black and white photography was my first passion, probably born more out of necessity, since color film and slide film was expensive to buy and process, whereas I could obtain black and white film, as well as process and print, at school for next to nothing. Most of my favorite rock concert photographers also shot black and white film, which to me made black and white the ultimate in cool. I guess for these reasons I still have an affinity for black and white images.

For most of the large concerts I shoot these days I stick with color images: the lights, the stages, the performers' clothes, all lend a great brilliance to the images, which color photography brings out and shows off well. But there are certain shots, performers, and some venues in which I prefer black and white images.

Since I only shoot in RAW even when setting my camera to shoot in black and white mode, when I import the images to the RAW converter they are rendered in color. So the last step in my post-processing is black and white conversion.

There are a number of different ways to convert your images to black and white, from using a module in your RAW conversion software to using Photoshop layers, filters, or plug-ins. There are also standalone applications as well.

Probably the most convenient way is to do the conversion right in the RAW conversion software. This is a nondestructive conversion since it only saves the black and white information as a sidecar file in the original RAW file, so you can go back and adjust the settings at any time. Doing the conversion in Lightroom 3 or Adobe Camera, RAW allows you to convert the image to grayscale, then you can adjust the luminosity of the different tones in the image, which gives you a lot of control. This is one of the most precise ways to do a black and white conversion.

10.8 *Doing the black and white conversion in the RAW converter is quick and easy. I pushed the red, yellow, and orange sliders up to bring out detail in the face.*

Another fairly precise way to convert your image to black and white is to use Photoshop. The most current Photoshop programs have a Black and White adjustment layer feature that works similarly to the technique I described in the previous paragraph.

Probably the easiest way to do it is to use a Photoshop filter. My favorite one is the Alien Skin Exposure 3 (also available as a standalone application). This program emulates different film types, adding grain and texture. You can also fine-tune the conversion by using individual sliders.

10.9 *Alien Skin Exposure 3 is a quick and easy Photoshop plug-in that allows you to emulate your favorite films or to create a look of your own.*

Another great program for black and white conversion is Nik Software's Silver Efex Pro 2. This is a very comprehensive package for doing black and white conversions. You can control almost everything to a T. You can do localized contrast and grain adjustments by using control points, and you can also view side by side comparisons.

10.10 *Nik Silver Efex Pro 2 is a very powerful tool for black and white conversions.*

CREDENTIALS AND MARKETING

Probably one of the most common questions I get from aspiring and fledgling photographers concerns how to get a photo pass. Attaining credentials and knowing how to market your photos is the only way you'll be able to make it in this business, which is becoming more and more cutthroat everyday.

In the past, before digital SLRs became affordable and before the Internet became a viable outlet for music journalism, attaining a photo pass was tricky, but there wasn't as much competition for spots in the photo pit. With the number of music fans out there today who look at a photo pass as simple way to get free concert tickets and to get closer to their favorite band, PR firms are inundated with requests from people who want photo passes. This makes the PR people who work for the bands a lot more stringent about who they let in to the photo pit.

The bottom line for PR firms is, "What can this photographer do for my band?" Obviously a photographer shooting for a major publication like *Rolling Stone* or *SPIN* will have no difficulty gaining access to photograph. Next up are photographers who work for regional publications, which may be daily, weekly, or monthly; these photographers generally don't have many problems gaining access since they can promote the band pretty effectively. Next down the line are online magazines, blogs, and music websites. The line starts getting a little blurred here, because there are many different levels of online presence. Obviously if you're shooting for a well-known online magazine you will be approved to shoot before someone who has a blog with a few dozen followers. Wire photographers who shoot for an agency are next in the line, although more and more PR firms are limiting the number of wire services that have access. This is due to the fact that the band's PR people don't have a lot of control over how the images are used once they are available for licensing through the image agency. The bottom of the list is freelancers who are shooting in order to market the images themselves; these photographers offer little gain to further the publicity of the band and are often denied photo pit access.

Sometimes venues will have a *house photographer*. This photographer works directly for the venue, which can often grant access to larger acts. However the PR firm can still limit whether a house photographer can shoot.

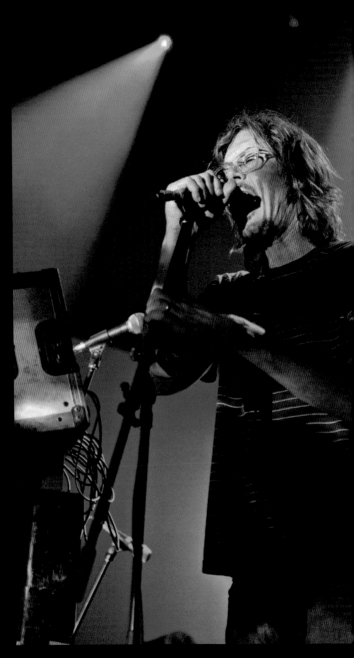

11.1 *Gibby Haynes of the Butthole Surfers performing at Emo's East in Austin, TX. Taken with a 28-70mm f/2.8D at 70mm; ISO 1000 for 1/125 at f/2.8, spot metering.*

The difficulty in gaining access to photograph increases exponentially the more famous a band is. Obviously stars the caliber of the Rolling Stones have little need to further their publicity, and photo passes are very difficult to obtain unless you're covering for a specific publication. The PR people for megastars like to control every aspect of their band's image, and this includes photographs of live performances. Often the PR people will go so far as to review your photos before allowing them to be used.

Fortunately for us there are more bands that are on their way up that can benefit from publicity, so there's no shortage of bands to photograph.

Not only does the proliferation of digital photographers make it more difficult to attain photo credentials, it also has an impact on the amount of money that music photographers can earn. As I mentioned, there are a lot of music fans out there who only want to get closer to their favorite bands, and they are willing to shoot in trade for a photo pass and a free ticket. Most bands, PR firms, and venues are becoming increasingly aware of this fact, so the prospect of finding paid gigs is dwindling. The days of making a living solely from photographing rock bands are pretty much over, so if you got into concert photography with the intentions of become rich and famous you may want to reconsider.

MAKING CONTACTS

So you have the gear, you've got the skill set needed, and you've even found an outlet to shoot for. Now the only thing standing in your way is that you have no idea who to contact to request a photo pass. This is one of the biggest obstacles to overcome on your quest to becoming a world-famous concert photographer.

The easiest way to find out whom to contact about procuring a photo pass is to make friends with some of the established local concert photographers. They can usually tell you who the best person to contact is and what is the best way to make contact.

There are, however, some local concert photographers who may be very tight with their information, and with some sound reasons. More photographers in the pit means less moving room for every other photographer. It gets pretty tight in there. Also, some established photographers don't want to deal with the "newbies," who can often get in the way, accidentally block your shot, trip you

up by leaving gear lying around, and worse. So don't pester these photographers, and mind your manners when you get in the pit to prove them wrong.

If for some reason you can't get the information from another photographer there are lots of different channels to go through. For the most part the entity you contact is dependent on what level the band or performer is at in their career. For most local acts just starting out you can simply show up at the club and shoot. When local acts start getting a little bigger, you can start by contacting the band directly and explaining your intentions. This will often land you a spot on the guest list and possibly get you a few drinks for your trouble as well. Some of the more popular local acts may have a manager that you can contact. The best way to find this information is by checking the band or performer's website.

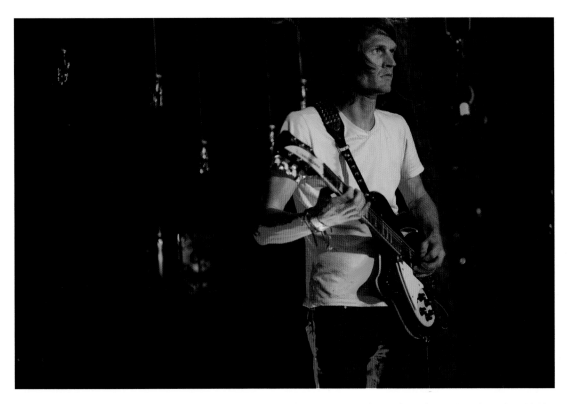

11.2 *Christian Bland of the Black Angels performing at Lustre Pearl in Austin, TX. Taken with a Nikon D700 with a Nikon 28-70mm f/2.8D at 65mm; ISO 3200 for 1/125 at f/2.8, spot metering.*

When a performer or band reaches the point where they have a pretty good following, they often start to tour regionally, usually across the state or in some cases within a few surrounding states. By this point the band usually has all of their business done through their management. Again, the best way to find the contact information is to check the website. Simply send an email explaining that you would like to photograph the band, and say what you will be using the photographs for, whether it's a magazine article, blog, or other outlet. Most regional touring bands won't even mind if you are taking pictures to build a portfolio. If this is the case, offer up a few select prints for them to use on their website. It helps if you have a link to some samples of your images so that that you can show the management you are a competent photographer and that your skills may be an asset to the artist's image.

Once a band has reached the status where they're touring nationally and playing more respected venues they start to get harder to reach. At this point and beyond the management becomes more involved and more concerned with controlling the public image of the artist, which includes determining which photographers and media outlets are allowed to cover the band or performer.

From here on out it's best to approach the *concert promoter*. The concert promoter is the person or company that is in charge of booking the artist into a certain venue, promoting the event, dealing with ticket sales, merchandise, and seeing to the wants and needs of the band or performers, such as handling details on the day of the show, and most of all ensuring that the concert is well attended so that the artist, venue, and hopefully the promoter all make a profit. The concert promoter is in direct contact with the management and the public relations firm, and one of his or her jobs is to handle press requests and to act as a liaison between the press (including photographers) and the artist, or more accurately the artist's management.

Finding out who is acting as the concert promoter isn't usually an exceedingly difficult task. Generally, most venues deal with a limited number of promoters, and often it's just one. Checking the advertisements online or even the printed concert posters you will usually see a byline such as *Dead Sailor Productions presents* or *Presented by Dead Sailor Productions*. For smaller acts there may be any number of concert promoters. Sometimes a concert promoter is just one person who enjoys music and wants to put on a show, and they do it independently. For the larger acts there's generally a promotion company involved. These are multileveled corporate-type structures that handle all of the logistics of putting on concerts that can cost millions of dollars to stage.

How it works with concert promoters is that you send them an email explaining your intent and then they pass it on to the artist's management. The management will approve or deny your request to shoot, and the concert promoter will email you back to let you know if you've been approved or not. It's a pretty simple process.

When contacting a concert promoter the best way is by email. They are busy, and if you think calling them will get a quicker response you are wrong. More often than not they will find your phone call more of an annoyance than anything. If they do take down your information when you call it's likely to be lost among the shuffle of their other daily paperwork. Remember, concert promoters do a lot more than handle press requests from photographers. The most convenient way for both you and them is email. This way you both have an electronic trail to follow.

What to include in an email photo pass request:

- **Subject line** – In the subject line include the reason for the email, the band or performer's name, the date, and location. Example: *Photo request for Tom Waits 12.07.2012 Johnsburg IL.* This immediately lets them know what the email is about. This is very important.

- **Name and Press affiliation** – First of all state your name and what outlet you are shooting for. Example: *Hello, this is John Smith, I'm the principal photographer for the Johnsburg Gazette.* This lets them know that you have a serious agenda.

- **Description of your Press affiliation** – This is just a quick rundown of what the entity you're shooting for is all about. Being detailed but to the point is key here. One thing that can help is to include what the readership or reach of the publication is. The more people that are going to be reached the more likely you will be granted access. Don't embellish, for they are likely to do a cursory search. Example: *The Johnsburg Gazette is the leading newspaper in the metropolitan Johnsburg area. We have a readership of over 125,000 people in both our print and online media.*

- **Description of the coverage intended** – Describe what the photos are going to be used for. You can also add some pertinent information about the scope of the article or the amount of coverage this photograph is likely to receive. Example: *The Johnsburg Gazette is planning to do a*

three-page article covering the upcoming Rolling Stones concert and it's impact on the local economy. We would love to photograph the upcoming show. The photographs are to be used in support of the aforementioned article.

When emailing a concert promoter keep it succinct and use proper grammar and punctuation. Sending a poorly worded request is a quick way to let them know that you aren't serious and your email will likely end up in the junk mail folder.

Another more direct route is to contact the artist's management or PR. It's a little more difficult to obtain this information for the most prominent artists, but for about 75% of the national touring performers you can find most of the information you need under the contacts link of their website. Sometimes a little digging is required. Often you can find information on who to contact from other photographers in concert photography groups on the Web, such as the Live Music group on flickr.com.

Generally the best person to contact is the publicist. More often than not if you contact the manager he or she will direct you to the publicist. The publicist is in charge of promoting the artist, the artist's music, coordinating press releases, and handling press requests and photo shoots, including live performances. The publicist wants to know that your work will help further the band or performer in some way, otherwise you are of no use to them and will likely be denied access.

Just as with the concert promoter the publicist (or manager if you went that route) will want to know the specific information of whom you are shooting for and what the images will be used for. When emailing a publicist follow the same outline mentioned above. Be sure to keep it professional.

11.3 *Social Distortion frontman Mike Ness performing at the 2011 Austin City Limits Music Festival in Austin, TX. Taken with a Nikon D700 with a Nikon 80-200mm f/2.8D at 80mm; ISO 3200 for 1/250 at f/2.8, spot metering.*

The ultimate goal for a concert photographer is to get his or her images published and hopefully get paid for them. If you're working for a local magazine, newspaper, or website you already have the means to get your images published, but you may want to reach a broader audience and possibly even more prestigious publications like *Rolling Stone* or *SPIN*. The major music magazines like *Rolling Stone* aren't in the habit of handing out assignments to relatively unknown photographers and publishing their work. They do, however, license images from photographers for use with some of their small to medium editorial features. These images are searched out and chosen by a photo editor.

Which brings us to the question, *where do photo editors find these images?* The short answer is from a wire service. *Wire service* is the generic term for a stock photography company or photo agency that carries editorial images, such as current music and entertainment photography. The way it works is that a photographer represented by the agency photographs the concert and submits the images. The agency then posts the images on the agency's website and markets them to their clients, which usually include any number of national and international publications both in print and on the Net. This is a great way to get published in the big music publications.

This leads us to the question of how one goes about signing on with an agency. There are a number of different agencies out there; Getty, Corbis, AP Images, Retna, WireImage, and FilmMagic are some of the most well known. Some of these agencies are subsidiaries of other agencies, and some of the agencies have agreements with the others wherein they carry the images of their partner agencies.

11.4 *My photo of Bon Iver (top) was used in* Rolling Stone *magazine. The image was placed through my agency, Corbis Images. This is a scan of the actual page of the magazine, which is known as a "tear sheet" in the trade.*

Agencies don't just sign up every photographer who makes an inquiry. Before even attempting to approach an agency about representation you need to build up an impressive portfolio. This doesn't mean your portfolio has to be filled with famous bands and performers, but it needs to be *good*. The editors at

the agency are going to want to see clean, well composed, and dynamic work. The goal of the agency is to sell photographs, and only the best images will be accepted, so if the agency takes a look at your portfolio and your photos look like a collection of snapshots it's not likely they'll take you on.

It generally takes many years of shooting concerts to gain enough experience to build up a portfolio that's good enough to show to a prospective agency. I shot concerts for more than ten years and built up a sizable portfolio before I approached my first agency and got signed on.

PORTFOLIO DEVELOPMENT

Developing your portfolio is a very important facet of being a concert photographer. A portfolio should showcase your very best work and be presented in a professional way. A portfolio shouldn't be a mishmash of random images you like, but should be a cohesive display of your finest work. A portfolio can be made of hard copies or can simply be a Web gallery. Here are a few pointers that will help you develop a more professional looking portfolio.

- *Exposure –* Be sure your images are well exposed. Underexposed and overexposed images will tell the editor that you don't quite have a grasp of the basic tenets of exposure.

- *Composition –* Choose strong, interesting compositions. Use the Rule of Thirds and leading lines, be sure that the background is uncluttered, and make the framing compelling. Remember that these images are going to be your first impression.

- *Colors –* Select vibrant images with strong bold colors, but be careful not to oversaturate to the point that it looks like it was overly manipulated in Photoshop. If you're going for black and white, choose bold images with high contrast, but pay close attention to shadow and highlight detail.

- *Avoid repetition –* Don't feature multiple shots of the same performers. The key is to show your versatility here. Find the one shot of the performer that you like best and use it. If you don't have enough photos of different performers to create a sizable portfolio you're probably not ready for an agency yet. Keep shooting and don't rush into to it.

One very important thing to do before you present your portfolio to an agency is to have it critiqued by other photographers, and be prepared to be disappointed. You may not like what you hear, but remember it's in your best interest to present the absolute best portfolio you can. The editor at the agency is going to look at your images in a detached manner, and if the images aren't all they could be they are going to pass you over.

Once you've submitted your portfolio the editors at the agency will take a look at it and decide if you're what they are looking for. If they decide they like what they see, then you'll be offered a contract. Generally a contract runs for one to two years.

The great thing about signing with an agency is that your images will have much more visibility to the important photo editors, which increases the likelihood of your images selling. However, the downside is that the visibility comes at a cost. Most agencies take a minimum of 50% of the licensing fees, and some agencies take more than 60%.

LEGAL CONCERNS

First off, I am not a lawyer and in no way should any of this be construed as legal advice. There are a number of different legal concerns that face concert photographers in the digital age. One of the most common questions that come up regard copyright and usage of images. You as the photographer own the copyright of your image the moment you press the shutter until you transfer or forfeit the rights.

Although you as the photographer own the copyrights to the images, this doesn't mean that you can do anything you want with the images. You are allowed to license the images for editorial use, but you may not use the photos for advertising purposes, nor can you use the images for commercial profit without the consent of the person in the photograph.

11.5 *Weird Al Yankovic performing in Austin, TX at Austin City Limits Live. Taken with a Nikon D700 with a Nikon 80-200mm f/2.8D at 200mm; ISO 3200 for 1/250 at f/2.8, spot metering. Weird Al's inclusion in this section does NOT infer that he requires a signed contract.*

This brings us to one of the most troublesome problems facing concert photographers today: the Rights Grab Contract.

The Rights Grab Contract is something that publicists, bands, and their management have begun to use increasingly in the past few years. Simply put, the band or performer's management requires that the photographer sign over any and all rights to their images in exchange for the privilege of photographing the band. This unscrupulous contract transfers complete ownership of the images to the musicians. The band can then use the images for anything they like with the photographer having absolutely no say in the matter. A band could conceivably use the images for a record cover, T-shirts, a billboard, and posters, generating millions of dollars of revenue for the performer and leaving the photographer out in the cold.

SAMPLE RIGHTS GRAB CONTRACT

The following is an example of the typical wording of a Rights Grab Contract. Generally, the contract states that the images can only be used for a specific publication and cannot be sold for any other use or used in any publication other than the one specified in the contract. Furthermore, this particular contract states that the performer doesn't even have to give the photographer credit for taking the photo, and also grants the band Power-of-Attorney to copyright the images through the U.S. Copyright Office. And the biggest slap in the face is that you grant the performer the rights to use YOUR name and likeness to market the image if they so desire.

Dated:_____

I, _____ (name of photographer) hereby

*agree to the following with respect to the photographs that I will take, or cause to be taken, of the musical group collectively known as **PERFORMER** ("you") on*

the date _____, (the "Photos"):

1. I have the limited right and permission to use certain Photos that have been approved by you solely in connection with one (1) article about you contained in

[State name of publication].

The Photos may be used only in an article, publication or other medium initially disseminated to the public within one year of the date of this agreement. I shall have no right to otherwise use or re-use the Photos in whole or in part, in any medium or for any purpose whatsoever, including, without limitation, promotion, advertising, and trade, without your written consent therefor.

2. I hereby acknowledge that you shall own all rights in the Photos, including the copyrights therein and thereto, and accordingly, I hereby grant, transfer, convey and assign to you all right, title and interest throughout the universe in perpetuity, including, without limitation, the copyright (and all renewals and extensions thereof), in and to the Photos. I agree that you shall have the right to exploit all or a part of the Photos in any and all media, now known or hereafter devised, throughout the universe, in perpetuity, in all configurations as you determine, without obtaining my consent and without any payment or consideration therefor. I understand that you will give me appropriate "photo credit" where possible. I understand further that all aspects of said "photo credit" shall be determined by you in your sole discretion and that failure to accord said "photo credit" shall not be deemed a breach of any obligation, express or implied. I further grant to you the right to use my name, likeness and biographical data in connection with the distribution, exhibition, advertising and exploitation of the Photos. I will, upon request, execute, acknowledge and deliver to you such additional documents as you may deem necessary to evidence and effectuate your rights hereunder, and I hereby grant to you the right as attorney-in-fact to execute, acknowledge, deliver and record in the U.S. Copyright Office or elsewhere any and all such documents if I shall fail to execute same within five (5) days after so requested by you.

These contracts turn over any and all rights that you have to the images. Oftentimes the contracts will even spell out that you cannot use the images for *anything* other than one single publication that you state in the contract. This means you cannot even use the images on your personal website or even in your portfolio without running the risk of legal action.

I urge all photographers not to sign these Rights Grab Contracts and to walk away from any band or performer that allows their management to implement such oppressive terms in a contract. This would be akin to the band turning over the copyright of their songs to their record label, and as no band would do such a thing they should not ask a visual artist such as a photographer to turn over the rights of his or her own creative work.

This being said, oftentimes photographers will be asked to sign a fairly standard *image use* contract that spells out that the images can only be used for editorial use and may not be used for any commercial use. This contract is fair, as it doesn't require the photographers to sign the rights of the images away. This contract is simply a way to cover the artist against a photographer commercially benefitting from the band or performer's likeness, which is illegal and immoral in any case.

index

Note: Page numbers followed by *f* indicate figures and *b* indicate boxes.